PLUM DANDI

Knits

SIMPLE DESIGNS
FOR LUXURY YARNS

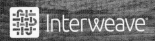
Interweave

fw

a content + ecommerce company

www.fwcommunity.com

21 20 19 18 17 5 4 3 2 1

Distributed in Canada by Fraser Direct
100 Armstrong Avenue | Georgetown, ON, Canada
L7G 5S4 | Tel: (905) 877-4411

Distributed in the U.K. & Europe by
F&W MEDIA INTERNATIONAL
F&W Media International Ltd. | Pynes Hill CourtPynes Hill, Rydon Lane | Exeter | EX2 5SP | United Kingdom
Tel: (+44) 1392 797680
E-mail: enquiries@fwmedia.com

SRN: 17KN04
ISBN-13: 978-1-63250-594-1

Editorial Director
Kerry Bogert

Editor
Maya Elson

Technical Editor
Therese Chynoweth

Art Director
Ashlee Wadeson

Cover + Interior Designers
Ashlee Wadeson + Pamela Norman

Photography
Harper Point Photography

Contents

Introduction

Life can be crazy at times... we know this firsthand! We created the Plum Dandi Group on Ravelry (named for our Ravelry handles, AliciaPlum [Alicia] and Dandiliongrl [Melissa]) not just for fans of our work—it was also created as a place where people could come be themselves, and encourage each other. Take a break together and unwind through friendship, laughter, and support. Days can spin by leaving us breathless and wondering where the hours went. Sometimes it's necessary to pause in life and just be still.

These pieces will invite you into that moment. Moments where you can savor a steaming mug of coffee on a screened porch overlooking the lake. Moments when the rain pelts your windows and a thick faded quilt, your knitting, and the woodstove are your only companions. Breezy autumn days where the crisp maple leaves crunch under your feet as you take a walk, drinking in the sunlight.

For this book we designed pieces that help you be present. Take a moment, sit with us, and let our story become yours. Knit each stitch slowly, thoughtfully. Relax with us in the simplicity. Classic pieces featuring simple lines and thoughtful details, and made with sumptuous yarns, will help you unwind and just be yourself.

Alicia & Melissa

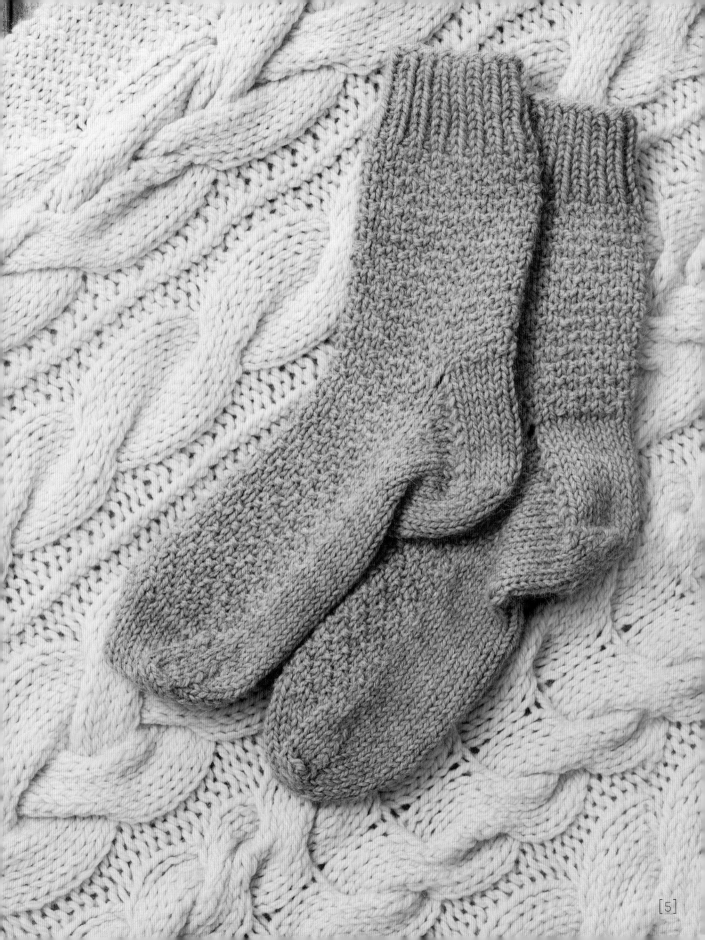

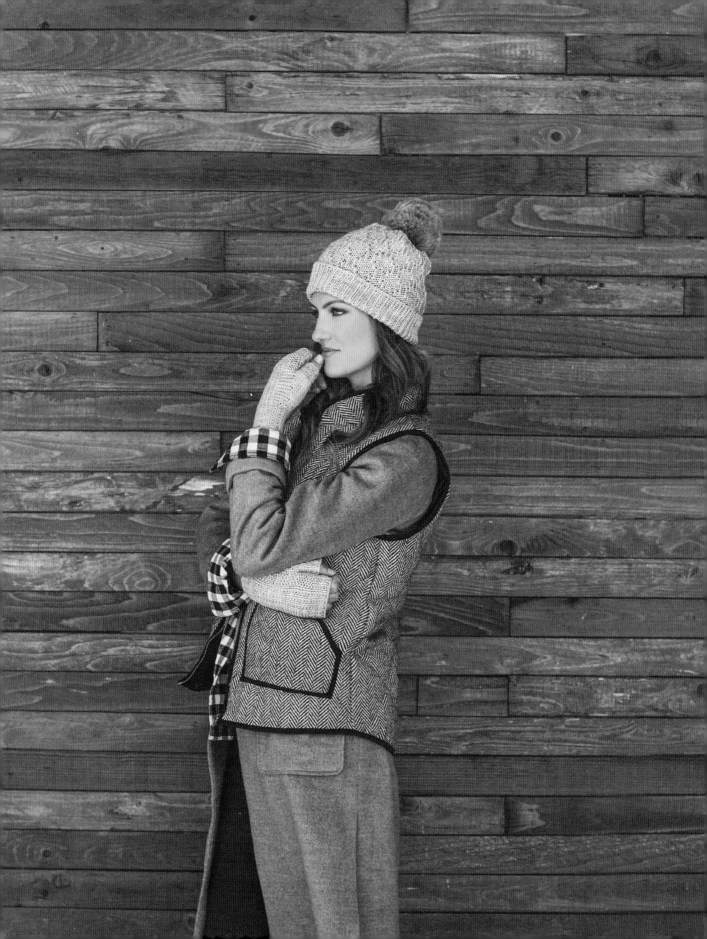

The Patterns

Fridley

In the minutes before the day begins you find stolen moments that are yours, and yours alone. With a flared bottom edge and button detail, these bulky cabled leg warmers transition effortlessly from bare legs to over your favorite pair of short boots. They are worked in the round from the top down.

FINISHED SIZE

10" (25.5 cm) circumference and 14" (35.5 cm) long.

YARN

Bulky weight [#6 Super Bulky].

Shown here: Dragonfly Fibers Super Traveller (100% superwash merino wool; 107 yd [98 m]/4 oz [113 g]: Birch, 3 skeins.

NEEDLES

Size U.S. 9 (5.5 mm): set of 4 double-pointed (dpn) or 32" (80 cm) or longer circular (cir) for Magic Loop method.

Size U.S. 11 (8 mm): set of 4 dpn or 32" (80 cm) or longer cir for Magic Loop method.

Adjust needle sizes if necessary to obtain the correct gauge.

NOTIONS

Stitch marker (m); cable needle (cn); tapestry needle; four 1" (25 mm) buttons; needle and thread for sewing on buttons.

GAUGE

Approximately 19 sts and 17½ rnds = 4" (10 cm) in patt with larger needles.

NOTES

— These legwarmers are worked in the round from the top down on double-pointed needles, and button at the ankles. A long circular needle may be used to work using the Magic Loop method (see Glossary) if desired.

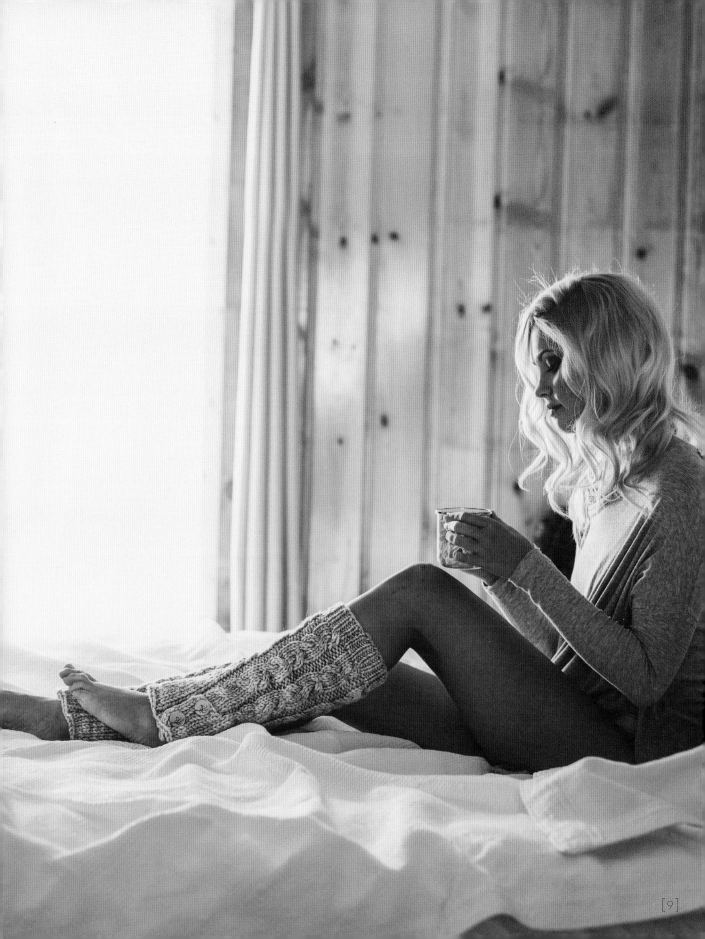

STITCH GUIDE

2/2 LC (2 over 2 left cross): Sl 2 sts to cn and hold in front of work, k2, k2 from cn.

2/2 RC (2 over 2 right cross): Sl 2 sts to cn and hold in back of work, k2, k2 from cn.

Cable Pattern (see chart)
(multiple of 8 sts)

Rnd 1: [P1, k2, 2/2 LC, p1] to end.

Rnds 2, 3, 4, 6, 8, 9, and 10: [P1, k6, p1] to end.

Rnd 5: Rep Rnd 1.

Rnd 7: [P1, 2/2 RC, k2, p1] to end.

Rnd 11: Rep Rnd 7.

Rnd 12: Rep Rnd 2.

Rep Rnds 1–12 for patt.

Legwarmers
(Make 2)

With smaller needles, CO 44 sts. Place marker (pm) and join for working in rnds, being careful not to twist sts.

Rnd 1: [K1, p1] to end of rnd.

Rep last rnd 8 more times.

Change to larger needles.

Next rnd: (inc) [K10, m1, k1] 4 times—48 sts.

Work Rnds 1–12 of Cable Patt 3 times (see Stitch Guide or chart). Piece should measure approximately 10½" (26.5 cm) from beg.

RIGHT CUFF (WORKED FLAT)

Beg working back and forth.

Row 1: (WS) K1, [p6, k2] to last 13 sts, p6, k1, CO 6 sts using Backward Loop method (see Glossary)—54 sts.

Rows 2, 6, 8, and 12: (RS) K6, p1, [k6, p2] to last 7 sts, k6, p1.

Rows 3, 5, 7, 9, and 11: K1, [p6, k2] to last 13 sts, p6, k1, p6.

Rows 4 and 10: (buttonhole) K3, yo, k2tog, k1, p1, [k6, p2] to last 7 sts, k6, p1.

Row 13: Rep Row 3.

BO all sts loosely in patt.

LEFT CUFF (WORKED FLAT)

At end of last rnd, CO 6 sts using Backward Loop method—54 sts.

Beg working back and forth.

Row 1: (WS) P6, k1, [p6, k2] to last 7 sts, p6, k1.

Rows 2, 6, 8, and 12: (RS) P1, [k6, p2] to last 13 sts, k6, p1, k6.

Rows 3, 5, 7, 9, and 11: Rep Row 1.

Rows 4 and 10: (buttonhole) P1, [k6, p2] to last 13 sts, k6, p1, k2, yo, k2tog k2.

Row 13: Rep Row 1.

BO all sts loosely in patt.

Finishing

Weave in ends. Block lightly to measurements. Sew buttons to cuffs opposite buttonholes.

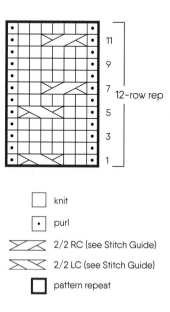

11

9

7 — 12-row rep

5

3

1

☐ knit

• purl

⟩⟨ 2/2 RC (see Stitch Guide)

⟩⟨ 2/2 LC (see Stitch Guide)

☐ pattern repeat

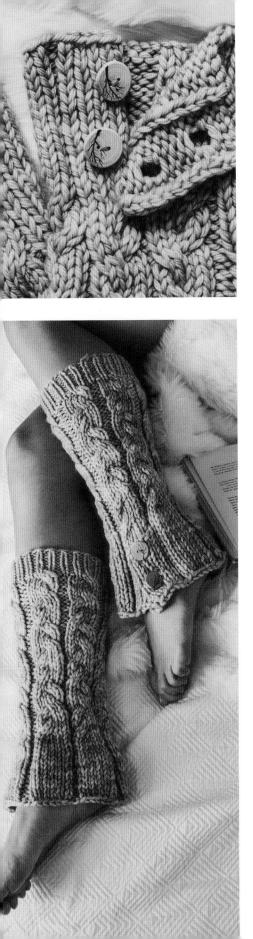
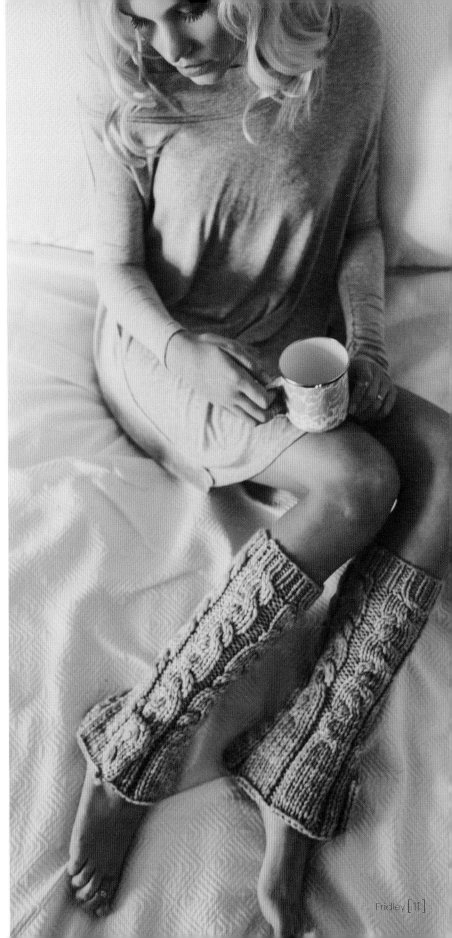

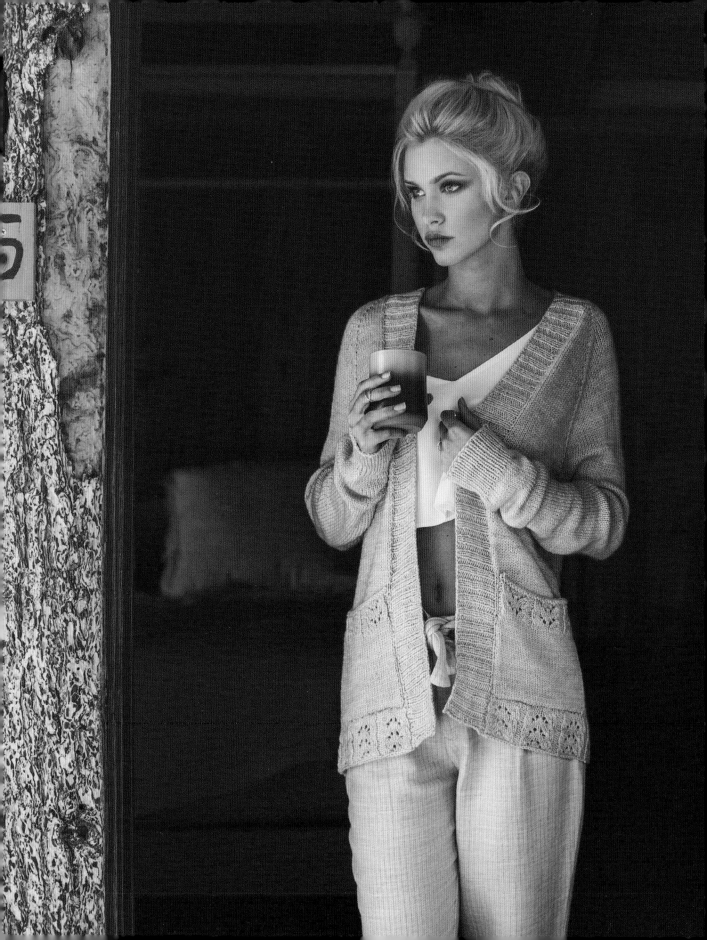

Genesee

Hints of the soft foliage on the forest floor are worked into this casual, top down cardigan. Roomy pockets, for warming your hands or keeping safe one of nature's secret treasures, are knit separately and sewn on.

FINISHED SIZES

28¾ (33, 36¼, 40½, 43¾, 47¾, 51¼, 55¼)" (73 [84, 92, 103, 111, 121.5, 130, 140.5] cm) bust circumference, with 7 (7¼, 7¾, 8, 8¼, 8¾, 9, 9½)" (18 [18.5, 19.5, 20.5, 21, 22, 23, 24] cm) front opening, and 23¼ (24½, 25½, 26¼, 27¼, 28½, 29½, 30¼)" (59 [62, 65, 66.5, 69, 72.5, 75, 77] cm) long.

Shown in size 33" (84 cm).

YARN

DK weight [#3 Light].

Shown here: Lakes Yarn & Fiber Hayden DK (100% merino; 280 yd [256 m]/4 oz [113 g]): Pigeon, 5 (6, 6, 7, 7, 8, 9, 9) skeins.

NEEDLES

Size U.S. 4 (3.5 mm): 36" and 48" (90 and 120 cm) circular (cir), and set of 4 or 5 double-pointed (dpn).

Size U.S. 6 (4 mm): 16" and 36" (40 and 90 cm) cir, and set of 4 or 5 dpn.

Adjust needle sizes if necessary to obtain the correct gauge.

NOTIONS

Stitch markers (m); waste yarn; tapestry needle.

GAUGE

21½ sts and 29 rows = 4" (10 cm) in St st with larger needles.

NOTES

— This cardigan is worked from the top down with raglan shaping.

— Long circular needles are used to accommodate the large number of stitches. Work back and forth.

— If you choose to work the sleeves using the Magic Loop method (see Glossary), use the longer circular needles instead of double-pointed needles.

Lace Pattern

(multiple of 11 sts + 2)

Row 1: (RS) [P2, k9] to last 2 sts, p2.

Rows 2 and 4: (WS) K2, [p9, k2] to end of row.

Row 3: [P2, k2tog, k2, yo, k1, yo, k2, ssk] to last 2 sts, p2.

Row 5: [P2, k1, k2tog, yo, k3, yo, ssk, k1] to last 2 sts, p2.

Row 6: Rep Row 2.

Rep Rows 1–6 for patt.

Cardigan

YOKE

With longer larger cir needle, CO 67 (69, 71, 73, 75, 77, 79, 81) sts. Do not join.

Set-up row: (WS) P3 for right front, place marker (pm), p12 for sleeve, pm, p37 (39, 41, 43, 45, 47, 49, 51) for back, pm, p12 for sleeve, pm, p3 for left front.

Inc row 1: (RS) [Knit to 1 st before m, M1R, k1, sm, k1, M1L] 4 times, knit to end of row—8 sts inc'd.

Next row: (WS) Purl.

Rep last 2 rows 22 (26, 28, 31, 33, 37, 39, 42) more times—251 (285, 303, 329, 347, 381, 399, 425) sts, with 26 (30, 32, 35, 37, 41, 43, 46) sts for each front, 58 (66, 70, 76, 80, 88, 92, 98) sts for each sleeve, and 83 (93, 99, 107, 113, 123, 129, 137) sts for back.

Inc row 2: (RS) [Knit to 1 st before m, M1R, k1, sm, knit to next m, sm, k1, M1L] twice, knit to end of row—4 sts inc'd.

Next row: (WS) Purl.

Rep last 2 rows 2 more times—263 (297, 315, 341, 359, 393, 411, 437) sts, with 29 (33, 35, 38, 40, 44, 46, 49) sts for each front, 58 (66, 70, 76, 80, 88, 92, 98) sts for each sleeve, and 89 (99, 105, 113, 119, 129, 135, 143) sts for back.

Yoke should measure 7¼ (8½, 9, 9¾, 10¼, 11½, 12, 12¾)" (18.5 [21.5, 23, 25, 26, 29, 30.5, 32.5] cm) from beg along center back.

DIVIDE BODY AND SLEEVES

Next row: (RS) Removing m as you go, *knit to m, place 58 (66, 70, 76, 80, 88, 92, 98) sleeve sts on waste yarn, CO 2 (3, 5, 7, 9, 10, 12, 14) sts using Backward Loop method (see Glossary), pm for side, CO 2 (3, 5, 7, 9, 10, 12, 14) sts; rep from * once more, knit to end of row—155 (177, 195, 217, 235, 257, 275, 297) sts, with 31 (36, 40, 45, 49, 54, 58, 63) sts for each front, and 93 (105, 115, 127, 137, 149, 159, 171) sts for back.

BODY

Work even in St st (knit on RS, purl on WS) until body measures 12½ (12½, 13, 13, 13½, 13½, 14, 14)" (31.5 [31.5, 33, 33, 34.5, 34.5, 35.5, 35.5] cm) from underarm, ending with a WS row.

Next row: (RS) Knit, and inc 1 (inc 1, inc 5, inc 5, dec 2, dec 2, inc 2, inc 2) st(s) evenly across—156 (178, 200, 222, 233, 255, 277, 299) sts.

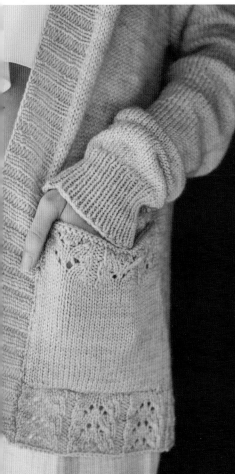

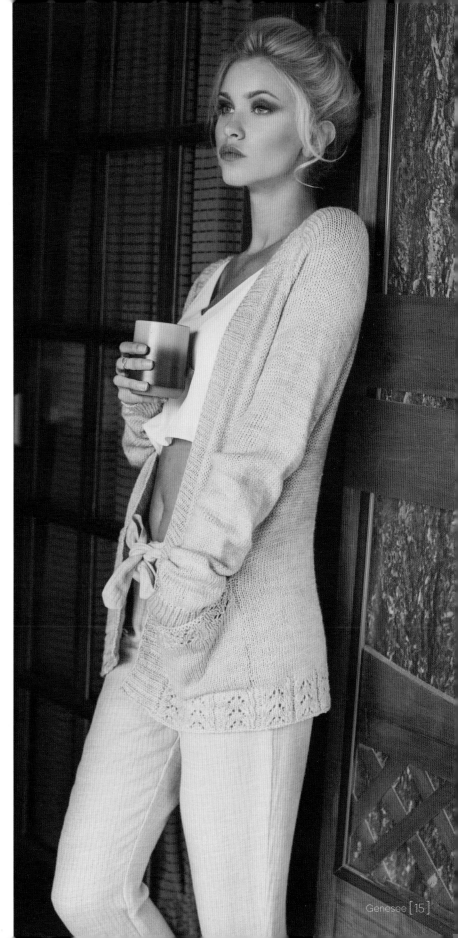

HEM

Change to shorter smaller cir needle.

Work in Lace Patt for 2½" (6.5 cm), ending with a WS row. BO all sts in patt.

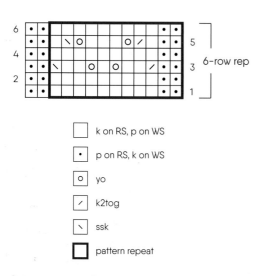

k on RS, p on WS

p on RS, k on WS

yo

k2tog

ssk

pattern repeat

SLEEVES (MAKE 2)

Note: *Sleeves are meant to be extra long. Please refer to schematic for length and make adjustments to length as needed.*

Return held 58 (66, 70, 76, 80, 88, 92, 98) sts for one sleeve to larger dpn or shorter cir needle. Beg at center of under-arm CO, pick up and knit 2 (3, 5, 7, 9, 10, 12, 14) sts in CO edge, knit sleeve sts, then pick up and knit 2 (3, 5, 7, 9, 10, 12, 14) sts along rem CO edge—62 (72, 80, 90, 98, 108, 116, 126) sts. Pm and join for working in the rnd.

Next rnd: Knit.

Dec rnd: K1, k2tog, knit to last 3 sts, ssk, k1—2 sts dec'd.

Change to dpn when there are too few sts to work comfortably on cir needle if using shorter cir needle.

Rep Dec rnd every 13 (10, 8, 7, 6, 4, 4) rnds 9 (12, 15, 6, 9, 6, 29, 15) times, then every 0 (0, 0, 6, 5, 4, 0, 3) rnds 0 (0, 0, 13, 13, 20, 0, 18) times—42 (46, 48, 50, 52, 54, 56, 58) sts rem.

Cont even until sleeve measures 17½" (44.5 cm), or 2½" (6.5 cm) less than desired length.

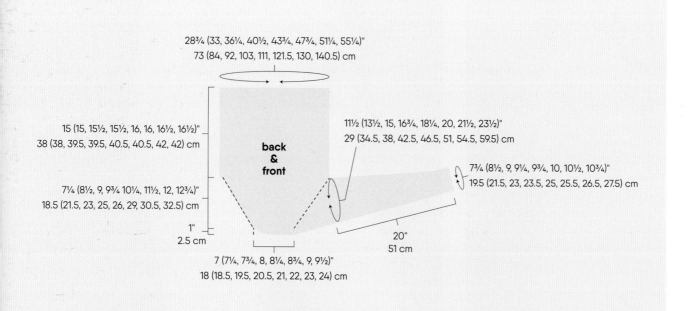

28¾ (33, 36¼, 40½, 43¾, 47¾, 51¼, 55¼)"
73 (84, 92, 103, 111, 121.5, 130, 140.5) cm

15 (15, 15½, 15½, 16, 16, 16½, 16½)"
38 (38, 39.5, 39.5, 40.5, 40.5, 42, 42) cm

back & front

11½ (13½, 15, 16¾, 18¼, 20, 21½, 23½)"
29 (34.5, 38, 42.5, 46.5, 51, 54.5, 59.5) cm

7¾ (8½, 9, 9¼, 9¾, 10, 10½, 10¾)"
19.5 (21.5, 23, 23.5, 25, 25.5, 26.5, 27.5) cm

7¼ (8½, 9, 9¾ 10¼, 11½, 12, 12¾)"
18.5 (21.5, 23, 25, 26, 29, 30.5, 32.5) cm

1"
2.5 cm

20"
51 cm

7 (7¼, 7¾, 8, 8¼, 8¾, 9, 9½)"
18 (18.5, 19.5, 20.5, 21, 22, 23, 24) cm

Change to smaller dpn or longer smaller cir needle for Magic Loop method.

Next rnd: *K1, p1; rep from * to end of rnd.

Rep last rnd until ribbing measures 2½" (6.5 cm). BO all sts loosely in ribbing.

FRONT EDGING

With smaller, longer cir needle and RS facing, pick up and knit 127 (130, 133, 138, 141, 144, 149, 154) sts evenly along right front (approximately 2 sts for every 3 rows), 10 sts along top of right sleeve, 36 (38, 40, 42, 44, 46, 48, 50) sts along back neck, 10 sts along top of left sleeve, then 127 (130, 133, 138, 141, 144, 149, 154) sts along left front—310 (318, 326, 338, 346, 354, 366, 378) sts.

Next row: (WS) *P2, k2; rep from * to last 2 sts, p2.

Next row: (RS) *K2, p2; rep from * to last 2 sts, k2.

Rep last 2 rows until ribbing measures 2" (5 cm). BO all sts loosely in ribbing.

POCKETS (MAKE 2)

With shorter larger cir needle, CO 35 sts. Do not join.

Beg with a WS row, work 35 rows in St st, ending with a WS row.

Work Rows 1–6 of Lace Patt 2 times. Knit 2 rows. BO all sts kwise.

Finishing

Weave in ends. Block pieces to measurements.

Sew pockets to each front above Lace Patt using mattress stitch (see Glossary).

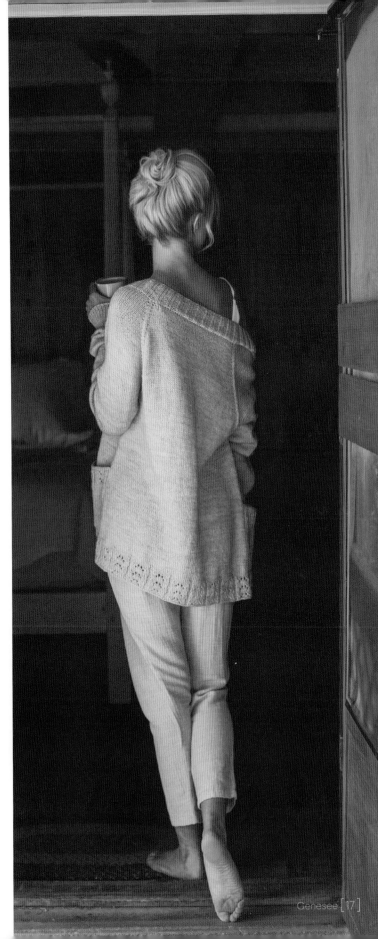

Sawyer

Elegant and versatile, this delicate shrug gently drapes the shoulders in one moment, then quietly transforms into a cascading cowl in the next. A bit of cashmere adds luxurious warmth. This piece is worked in the round from the bottom up.

FINISHED SIZE

36" (91.5 cm) bottom circumference, 20" (51 cm) top circumference, and 17" (43 cm) long.

YARN

Aran weight [#4 Medium].

Shown here: Western Sky Knits MCN Aran (80% merino wool, 10% polyamide, 10% cashmere; 181 yd [166 m]/3½ oz [100 g]): Platinum, 3 skeins.

NEEDLES

Size U.S. 7 (4.5 mm): 24" (60 cm) circular (cir).

Size U.S. 9 (5.5 mm): 24" (60 cm) cir.

Adjust needle size if necessary to obtain the correct gauge.

NOTIONS

Stitch marker (m); tapestry needle.

GAUGE

18 sts and 20 rnds = 4" (10 cm) in Lace Patt with larger needles.

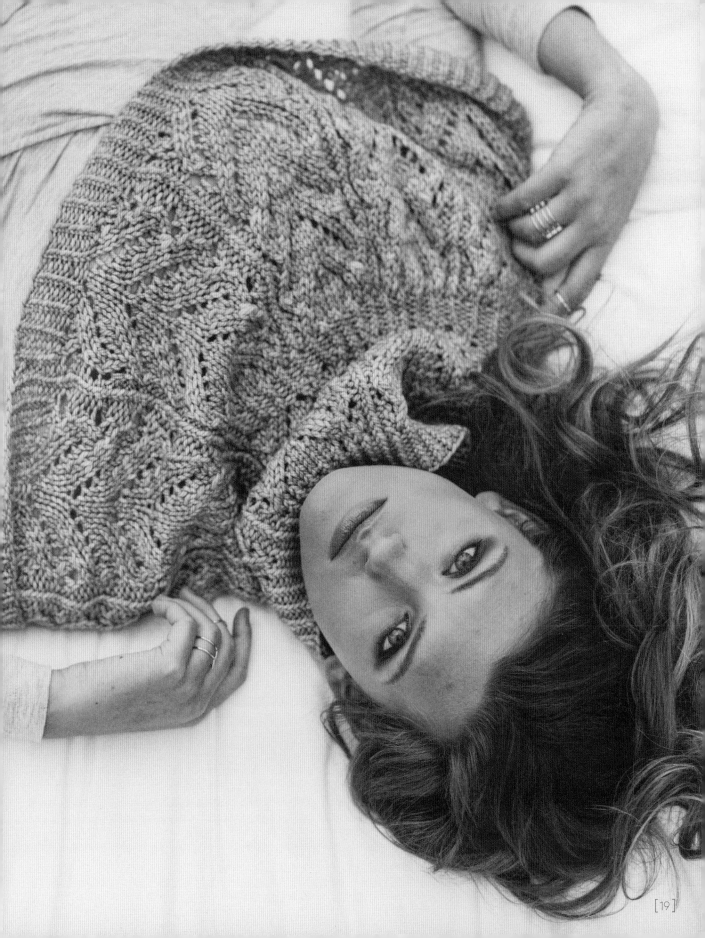

STITCH GUIDE

Lace Pattern

(multiple of 18 sts)

Rnd 1: *[K2tog, k1, yo, k1] twice, yo, k1, skp, k1, yo, k1, skp, p1, k1–tbl, p1; rep from * to end.

Rnd 2: *K15, p1, k1–tbl, p1; rep from * to end.

Rnd 3: *Yo, skp, k1, k2tog, k1, yo, k3, yo, k1, skp, k1, k2tog, yo, p1, k1–tbl, p1; rep from * to end.

Rnds 4 and 6: *P1, k13, p2, k1–tbl, p1; rep from * to end.

Rnd 5: *P1, yo, k3tog, k1, yo, k5, yo, k1, s2kp, yo, p2, k1–tbl, p1; rep from * to end.

Rnd 7: *P1, k2tog, k1, yo, k7, yo, k1, skp, p2, k1–tbl, p1; rep from * to end.

Rnd 8: Rep Rnd 4.

Rep Rnds 1–8 for patt.

18-st rep

	knit		↘	skp
	purl		ㅅ	k3tog
	k1–tbl		∧	s2kp
	yo			pattern repeat
	k2tog			

Collar

With larger needles, CO 162 sts. Place marker (pm) and join for working in rnds, being careful not to twist sts.

Rnd 1: *K1–tbl, p1; rep from * to end of rnd.

Rep Rnd 1 nine more times.

Work Rnds 1–8 of Lace Patt (see Stitch Guide or chart) 5 times. Piece should measure approximately 9¼" (23.5 cm) from beg.

Dec rnd: [K2tog, k1] 9 times, [k2tog] 53 times, [k2tog, k1] 9 times, k2tog—90 sts rem.

Change to smaller needle.

Work 5 rnds in k1–tbl, p1 ribbing.

Change to larger needle.

Work Rnds 1–8 of Lace Patt 4 times.

Change to smaller needle.

Work 8 rnds in k1–tbl, p1 ribbing.

BO all sts loosely in ribbing.

Finishing

Weave in ends. Block to measurements.

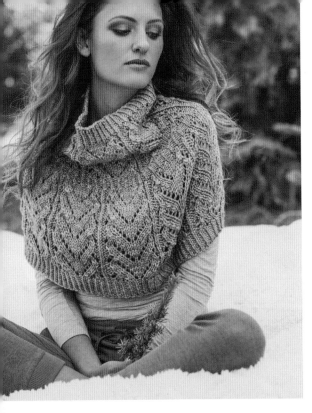
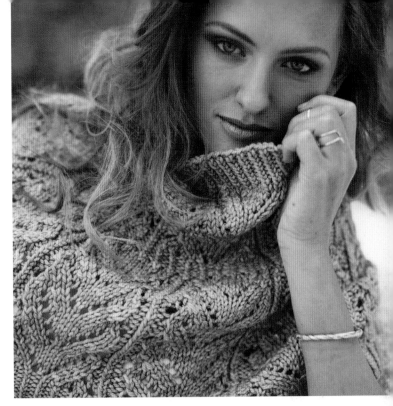
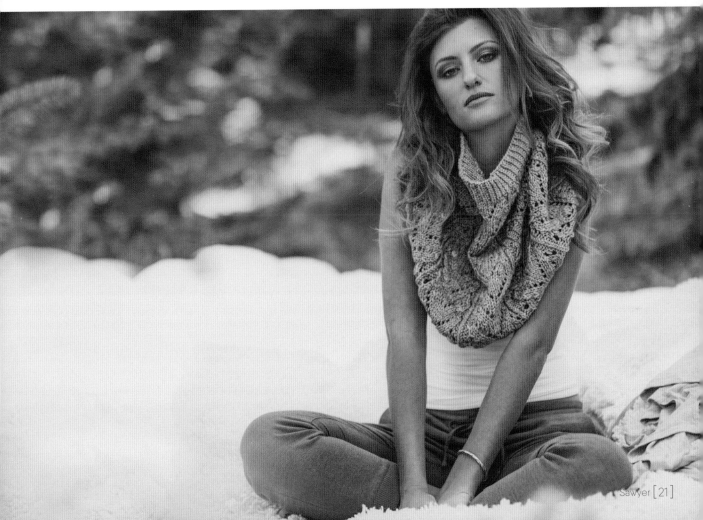

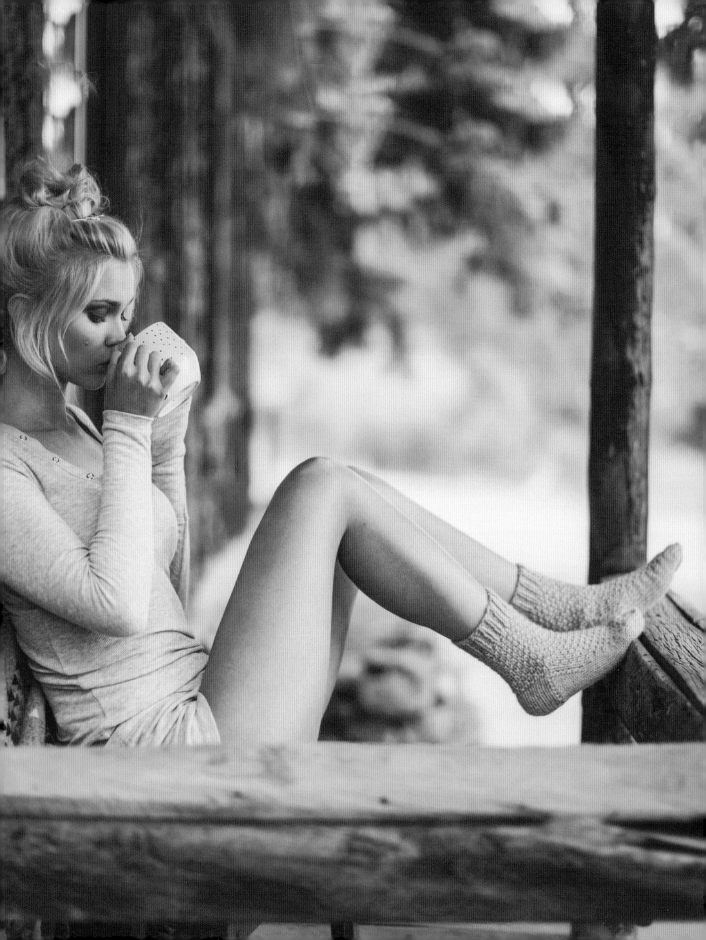

Lyndon

Textured and rustic, these socks are perfect for warming toes by the woodstove and padding silently across the floor when everyone else sleeps. The Lyndon socks are worked from the top down, with the heel flap worked in short rows.

FINISHED SIZE

7¼" (18.5 cm) foot circumference.

YARN

Chunky weight [#5 Bulky].

Shown here: Berroco Ultra Alpaca Chunky (50% alpaca, 50% wool; 131 yd [129 m]/3½ oz [100 g]): #7214 Steel Cut Oats, 2 skeins.

NEEDLES

Size U.S. 7 (4.5 mm): set of 4 or 5 double-pointed (dpn), or 32" (80 cm) circular (cir) for working in Magic Loop method.

Size U.S. 9 (5.5 mm): set of 4 or 5 dpn, or 32" (80 cm) cir for working in Magic Loop method.

Adjust needle size if necessary to obtain the correct gauge.

NOTIONS

Stitch markers (m); waste yarn; tapestry needle.

GAUGE

18 sts and 24 rnds = 4" (10 cm) in St st with larger needles.

17 sts and 24 rnds = 4" (10 cm) in Alternating Dot St with larger needles.

STITCH GUIDE

Alternating Dot Stitch

(multiple of 2 sts)

Rnd 1: Knit.

Rnd 2: *K1, p1; rep from * to end.

Rnd 3: Knit.

Rnd 4: *P1, k1; rep from * to end.

Rep Rnds 1–4 for patt.

Reverse Fisherman's Rib

(multiple of 2 sts)

Rnd 1: *K1, p1; rep from * to end.

Rnd 2: *K1, sl 1 wyf; rep from * to end.

Rep Rnds 1 and 2 for patt.

Socks
(Make 2)

With smaller needles, CO 32 sts using Long Tail method (see Glossary). Place marker (pm) and join for working in rnds, being careful not to twist sts.

Next rnd: *K1, p1; rep from * to end of rnd.

Rep last rnd until ribbing measures 2" (5 cm) from beg.

Change to larger needles.

Work in Alternating Dot St until piece measures 6½" (16.5 cm) from beg.

HEEL FLAP

Row 1: (RS) Work 16 sts in patt and place on waste yarn for instep, sl 1, knit to end of row—16 sts rem.

Row 2: (WS) Sl 1, purl to end of row.

Row 3: Sl 1, knit to end of row.

Work 14 more rows as established. Heel flap should measure 2¾" (7 cm).

TURN HEEL

Row 1: Sl 1, k8, ssk, k1, turn—1 st dec'd.

Row 2: Sl 1, p3, p2tog, p1, turn—1 st dec'd.

Row 3: Sl 1, knit to 1 st before last turn, ssk, k1, turn—1 st dec'd.

Row 4: Sl 1, purl to 1 st before last turn, p2tog, p1, turn—1 st dec'd.

Rep last 2 rows once more—10 sts rem.

GUSSET

With RS facing, knit 10 heel sts, pick up and knit 9 sts along side of heel, pm, work 16 held sts for instep, pm, pick up and knit 9 sts along rem side of heel, then k5—44 sts. Pm for beg of rnd. Rnds beg at center of foot under heel.

Rnd 1: Knit to m, sm, work in established patt to m, sm, knit to end of rnd.

Rnd 2: (dec) Knit to 3 sts before m, ssk, k1, sm, work to next m, sm, k1, k2tog, knit to end of rnd—2 sts dec'd.

Rep last 2 rnds 5 more times—32 sts rem.

FOOT

Cont even in established patt until piece measures approximately 1¼" (3.2 cm) short of desired length.

Next rnd: Remove m, k8, pm for new beg of rnd.

Dec rnd: *K1, ssk, k10, k2tog, k1; rep from * once more—4 sts dec'd.

Next rnd: Knit.

Rep last 2 rnds 3 more times—16 sts rem.

Rearrange sts if necessary with 8 instep sts on one needle, and 8 sole sts on second needle. Cut yarn, leaving a 16" (40.5 cm) tail. Graft sts tog using Kitchener St (see Glossary).

Finishing

Weave in ends. Block to measurements.

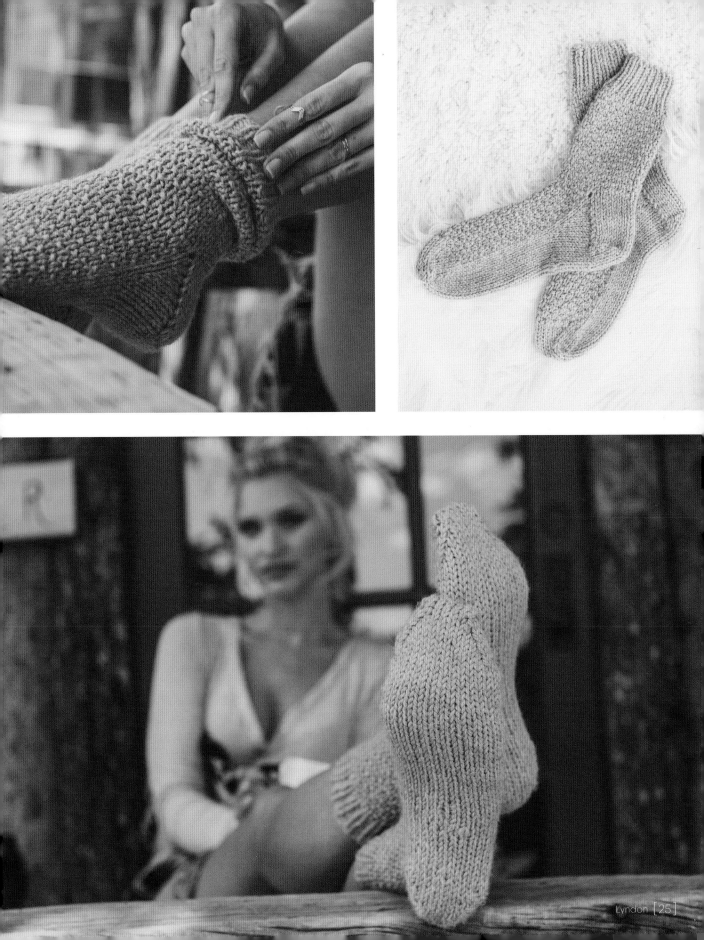

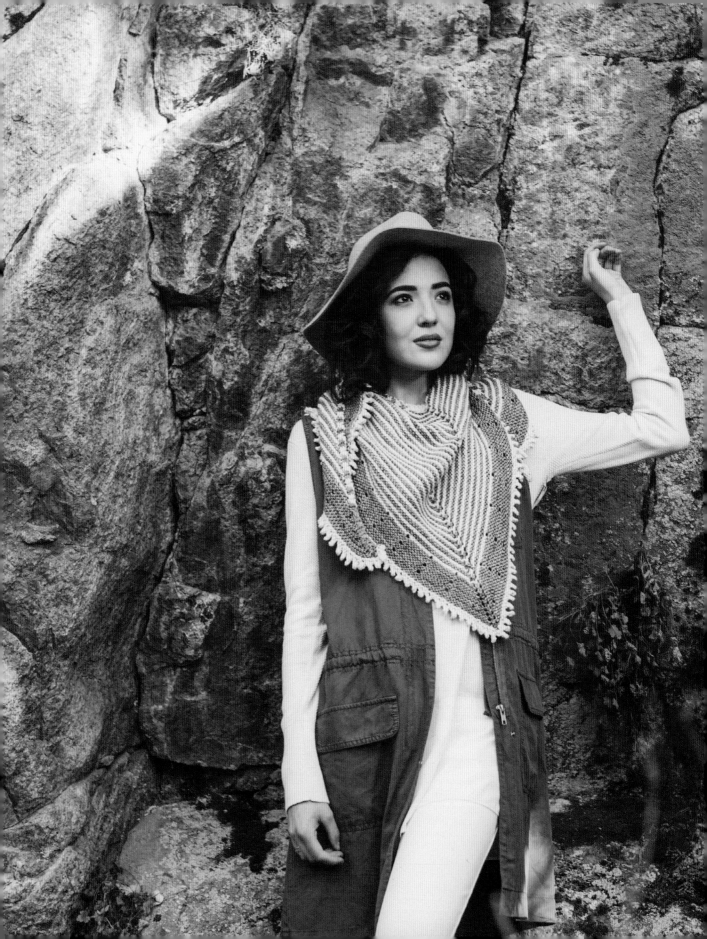

Ramsey

You wake feeling refreshed. Adventure calls and you are ready to answer. Knit with a silky cashmere blend, this shawl is the perfect accessory for heading out and discovering what lies ahead. Stripes, eyelets, and a simple yet interesting bind-off add charm to this versatile piece.

FINISHED SIZE

58" (147.5cm) wide along top edge and 22" (56 cm) long.

YARN

Worsted weight [#4 Medium].

Shown in: Julie Asselin Hektos (75% merino wool, 15% cashmere, 10% silk; 200 yd [183 m]/4 oz [115 g]): Natural (MC) and Cove (CC), 2 skeins each.

NEEDLES

Size U.S. 7 (4.5 mm): 48" (122 cm) circular (cir).

Adjust needle size if necessary to obtain the correct gauge.

NOTIONS

Stitch markers (m); tapestry needle.

GAUGE

16 sts and 38 rows = 4" (10 cm) in Garter st.

NOTES

— Increases on every row create a shallow depth to this shawl, which makes it effortless to wrap around the neck.

STITCH GUIDE

Note: Visual charts for Chart A and Chart B follow on page 30.

Chart A

(multiple of 8 sts)

Row 1: (RS) Yo, [k2, yo, k2tog, k4] to m, yo—2 sts inc'd.

Row 2 and all other WS rows: Knit to m, yo—1 st inc'd each row.

Rows 3 and 5: Yo, knit to m, yo—2 sts inc'd each row.

Row 7: Yo, k6, [k2, yo, k2tog, 4] to 3 sts before m, k3, yo—2 sts inc'd.

Rows 9 and 11: Rep Row 3—2 sts inc'd each row.

Row 13: Yo, k4, [k2, yo, k2tog, k4] to 6 sts before m, k2, yo, k2tog, k2, yo—2 sts inc'd.

Rows 15 and 17: Rep Row 3—2 sts inc'd each row.

Row 18: Knit to m, yo—1 st inc'd.

Chart B

(multiple of 8 sts)

Row 1: (RS) Yo, [k4, yo, k2tog, k2] to m, yo—2 sts inc'd.

Row 2 and all other WS rows: Yo, knit to m—1 st inc'd each row.

Rows 3 and 5: Yo, knit to m, yo—2 sts inc'd each row.

Row 7: Yo, k3, [k4, yo, k2tog, k2] to 6 sts before m, k4, yo, k2tog, yo—2 sts inc'd.

Rows 9 and 11: Rep row 3—2 sts inc'd each row.

Row 13: Yo, k2 yo, k2tog, k2, [k4, yo, k2tog, k2] to 4 sts before m, k4, yo—2 sts inc'd.

Rows 15 and 17: Rep row 3—2 sts inc'd each row.

Row 18: Yo, knit to m—1 st inc'd.

Shawl

GARTER TAB

With MC, CO 3 sts.

Work 11 rows in Garter st (knit every row). Do not turn at end of last row.

Next row: (RS) Rotate piece 90 degrees to the right, pick up and knit 5 sts along side edge, rotate piece 90 degrees to the right, then pick up and knit 3 sts along CO edge—11 sts.

Set-up row: (WS) K3, place marker (pm), k2, pm, k1, pm, k2, pm, k3.

BODY

Row 1: (RS) K3, sm, yo, knit to m, yo, sm, k1, sm, yo, knit to m, yo, sm, k3—4 sts inc'd.

Row 2: (WS) K3, sm, yo, knit to last 3, sts, yo, sm, k3—2 sts inc'd.

Rows 3 and 4: Join CC and rep Rows 1 and 2—6 sts inc'd.

Rows 5 and 6: With MC, rep Rows 1 and 2—6 sts inc'd.

Loosely carrying unused yarn along side of work, rep last 4 rows 21 times more, then rep Rows 3 and 4 once more—287 sts.

Next row: (RS) With MC, k3, sm, yo, knit to m, yo, sm, k1, sm, yo, knit to m, yo, sm, k3—291 sts.

Next row: (WS) K3, sm, yo, knit to m, yo, sm, k1, sm, yo, knit to m, yo, sm, k3—295 sts.

Change to CC.

BORDER

Row 1: (RS) K3, sm, work Row 1 of Chart A to m, sm, k1, sm, work Row 1 of Chart B to m, sm, k3—4 sts inc'd.

Row 2: (WS) K3, sm, work Row 2 of Chart B to m, sm, k1, sm, work Row 2 of Chart A to m, sm, k3—2 sts inc'd.

Work Rows 3–18 of charts as established—349 sts.

Change to MC.

Next row: (RS) K3, sm, yo, knit to m, yo, sm, yo, k1, sm, knit to m, yo, sm, k3—353 sts.

Next row: (WS) K3, sm, yo, knit to last 3 sts, yo, k3—355 sts.

Work elongated picot bind-off as foll: BO 2 sts, *use Cable method (see Glossary) to CO 3 sts, BO 5 sts; rep from * to end.

Finishing

Weave in ends. Block to measurements.

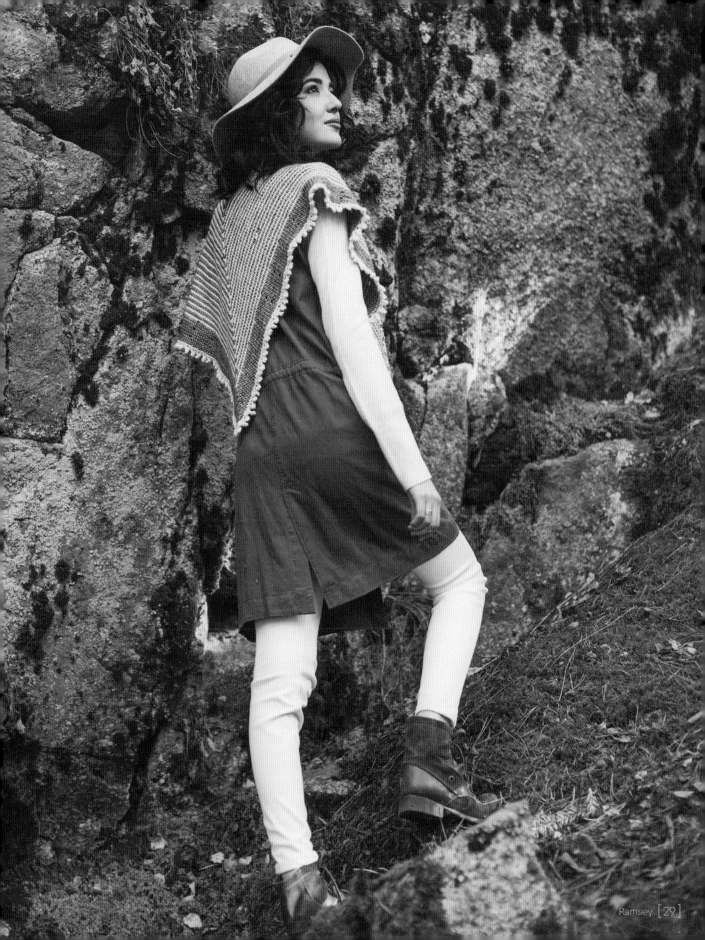

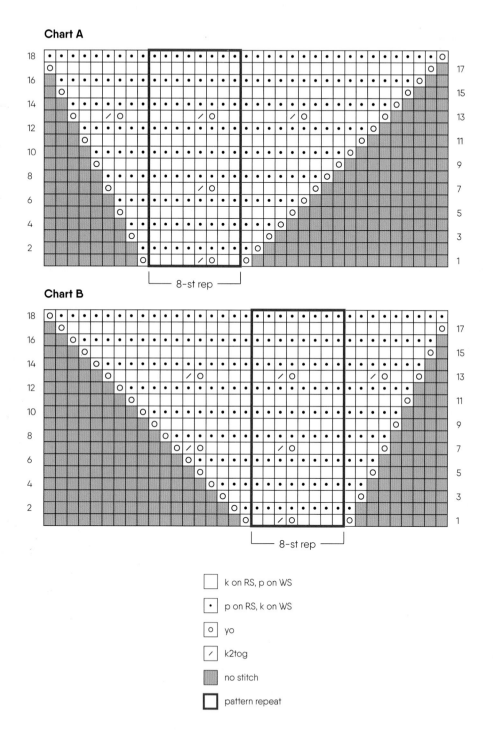

Chart A

8-st rep

Chart B

8-st rep

	k on RS, p on WS
•	p on RS, k on WS
o	yo
∕	k2tog
▨	no stitch
▢	pattern repeat

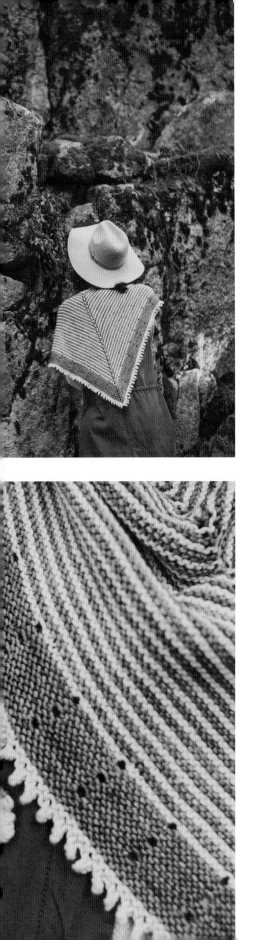
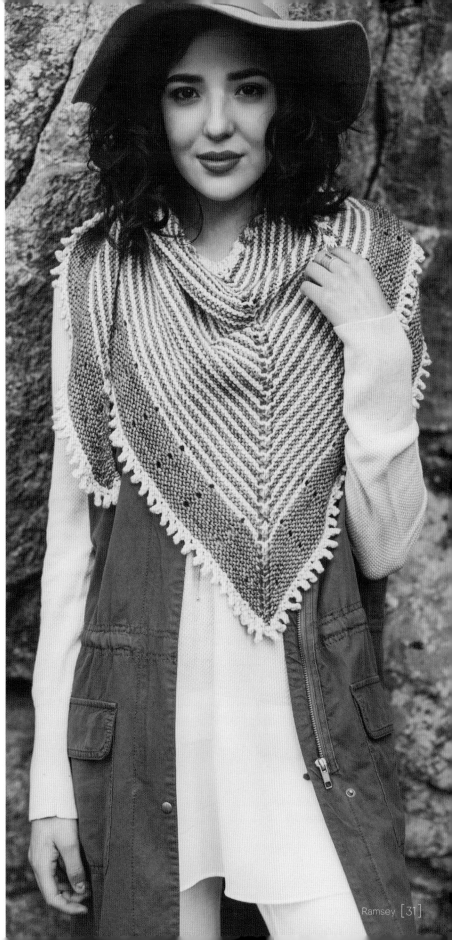

Exeter

The sharp air of autumn is chased away by the smoky crackle of a bonfire. Hand whittled twigs serve as the perfect toasting instrument for classic s'mores to wind down the day. The intersection of marshmallow and branch are represented along the surface of the Exeter mitts. Knit in a soft yet sturdy superwash merino, these mitts are worked in the round, from the bottom up. Thumb stitches are placed on hold and then worked in the round after the body is complete.

FINISHED SIZE

6¼" (16 cm) hand circumference and 7" (18 cm) long.

YARN

DK weight [#3 Light].

Shown here: Lakes Yarn & Fiber Lochsa DK (100% superwash merino wool; 280 yd [256 m]/4 oz [113 g]): Wapiti, 1 skein.

NEEDLES

Size U.S. 5 (3.75 mm): set of 4 or 5 double-pointed (dpn).

Size U.S. 7 (4.5 mm): set of 4 or 5 dpn.

Adjust needle sizes if necessary to obtain the correct gauge.

NOTIONS

Stitch markers (m); stitch holder; tapestry needle.

GAUGE

21 sts and 39 rnds = 4" (10 cm) in Garter st with larger needles.

Mitts

With smaller dpn, CO 32 sts using Long Tail method (see Glossary). Place marker (pm) and join for working in rnds, being careful not to twist sts.

Work in Beaded Rib for 2" (5 cm), ending with Rnd 1.

Change to larger dpn.

Set-up rnd: K4, M1R, pm, k7, pm, k9, M1R, pm, k7, pm, k5—34 sts.

Next rnd: P5, sm, [k1, p1] 3 times, k1, sm, p10, sm, [k1, p1] 3 times, k1, sm, p5.

THUMB GUSSET

Set-up rnd: Knit to last st, pm for thumb gusset, M1R—35 sts.

Inc rnd: Work 5 sts in Garter st (knit 1 rnd, purl 1 rnd), sm, [k1, p1] 3 times, k1, sm, work 10 sts in Garter st, sm, [k1, p1] 3 times, k1, sm, work 5 sts in Garter st, sm, M1R, knit to m, M1L—2 sts inc'd.

Next 2 rnds: Work in established patt to m, sm, knit to end.

Rep last 3 rnds 6 more times—49 sts, with 15 sts for thumb gusset. Piece should measure approximately 4¾" (12 cm) from beg.

Next rnd: Work in established patt to thumb gusset m, remove m, place 15 gusset sts on holder—34 sts rem.

Next rnd: Work 5 sts in Garter st, sm, work 7 sts in Beaded Rib, sm, work 10 sts in Garter st, sm, work 7 sts in Beaded Rib, sm, work last 5 sts in Garter st.

Cont in established patt until piece measures approximately 1" (2.5 cm) above gusset, ending with Rnd 2 of Beaded Rib.

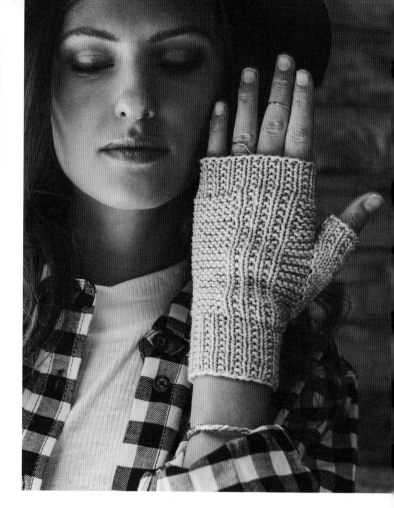

Change to smaller dpn. Work in Beaded Rib over all sts for 1" (2.5 cm), remove all m as you come to them, except beg-of-rnd m, and ending with Rnd 2 of Beaded Rib.

BO all sts in patt.

THUMB

Return held 15 thumb sts to smaller dpn, pick up and knit 2 sts in gap at top of opening, pm and join for working in rnds—17 sts. Distribute sts evenly over 3 or 4 dpn.

Work in Beaded Rib until thumb measures approximately ¾" (2 cm), ending with Rnd 2 of patt.

BO all sts in patt.

Finishing

Weave in ends. Block lightly to measurements.

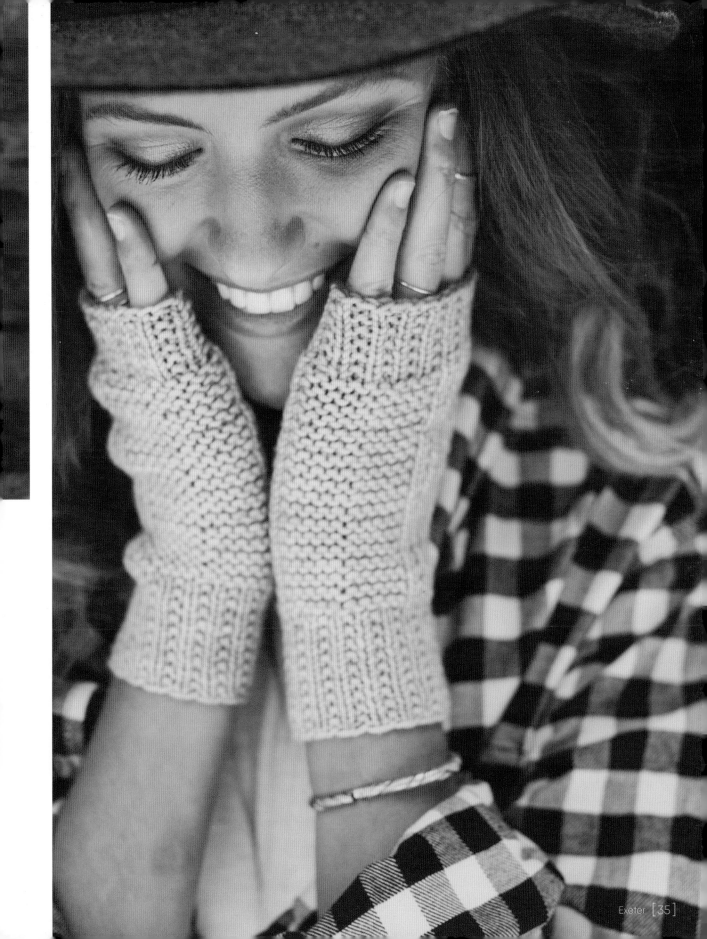

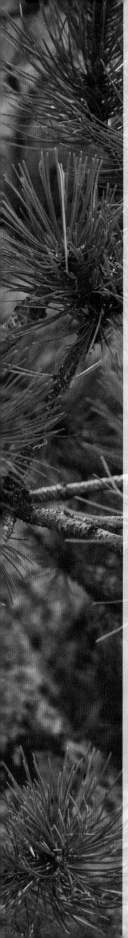

Bethel

The sun sets slowly over a jagged mountain ridge. Wanderlust is satisfied as each marked peak is breathtakingly observed. The Bethel headband is a minimal piece made of thick merino wool that will keep your ears warm and your load light for exploring. Worked flat and seamed, this quick headband is a fun knit using minimal yardage.

FINISHED SIZE

19" (48.5 cm) circumference and 3¼" (8.5 cm) tall.

YARN

Chunky weight [#5 Bulky].

Shown here: Madelinetosh Tosh Chunky (100% superwash merino wool; 165 yd [151 m]): Paper, 1 skein.

NEEDLES

Size U.S. 7 (4.5 mm).

Adjust needle size if necessary to obtain the correct gauge.

NOTIONS

Tapestry needle.

GAUGE

18 sts and 26 rows = 4" (10 cm) in St st.

NOTES

— Headband is worked flat to desired length, then ends are seamed after binding off.

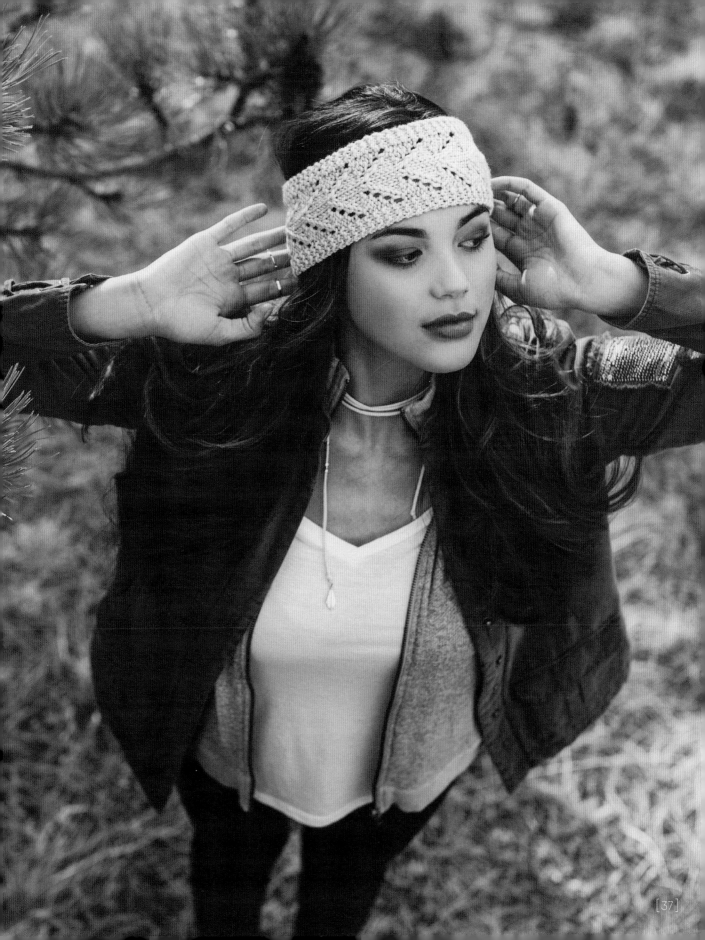

STITCH GUIDE

Lace Pattern

(panel of 16 sts)

Row 1: (RS) K3, yo, ssk, 6, k2tog, yo, k3.

Row 2: (WS) K4, p8, k4.

Row 3: K3, p1, yo, ssk, k4, k2tog, yo, p1, k3.

Row 4: K5, p6, k5.

Row 5: K3, p2, yo, ssk, k2, k2tog, yo, p2, k3.

Row 6: K6, p4, k6.

Row 7: K3, p3, yo, ssk, k2tog, yo, p3, k3.

Row 8: K7, p2, k7.

Rep Rows 1–8 for patt.

Headband

CO 16 sts using Long Tail method (see Glossary).

Work Rows 1–8 of Lace Patt (see Stitch Guide or chart)
until piece measures approximately 19" (48.5 cm) from beg,
ending with Row 8 of patt. BO all sts kwise.

Finishing

Weave in ends. Block to measurements. Graft CO edge to
BO edge (see Glossary).

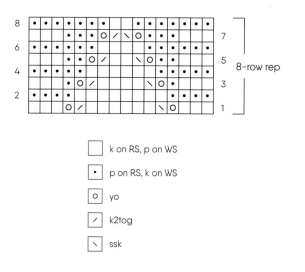

8-row rep

☐ k on RS, p on WS

• p on RS, k on WS

○ yo

╱ k2tog

╲ ssk

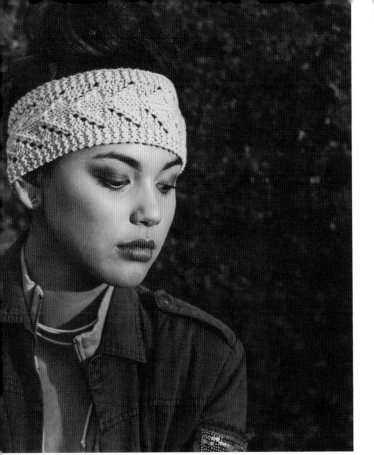
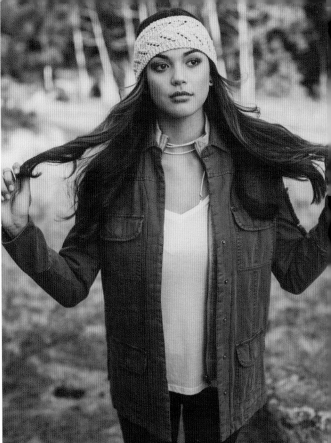
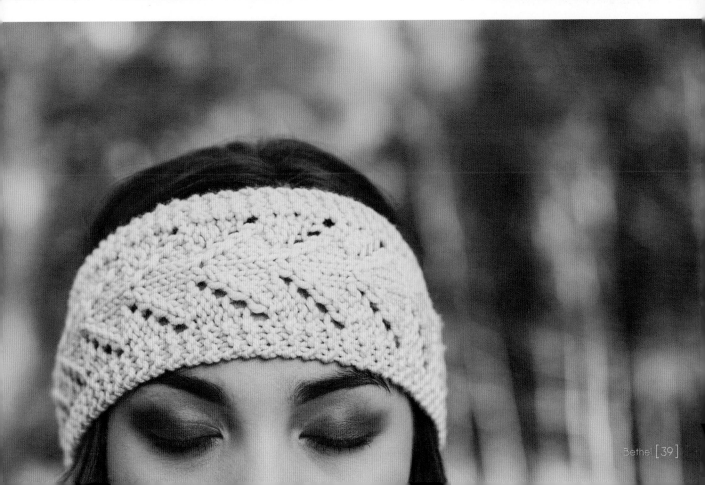

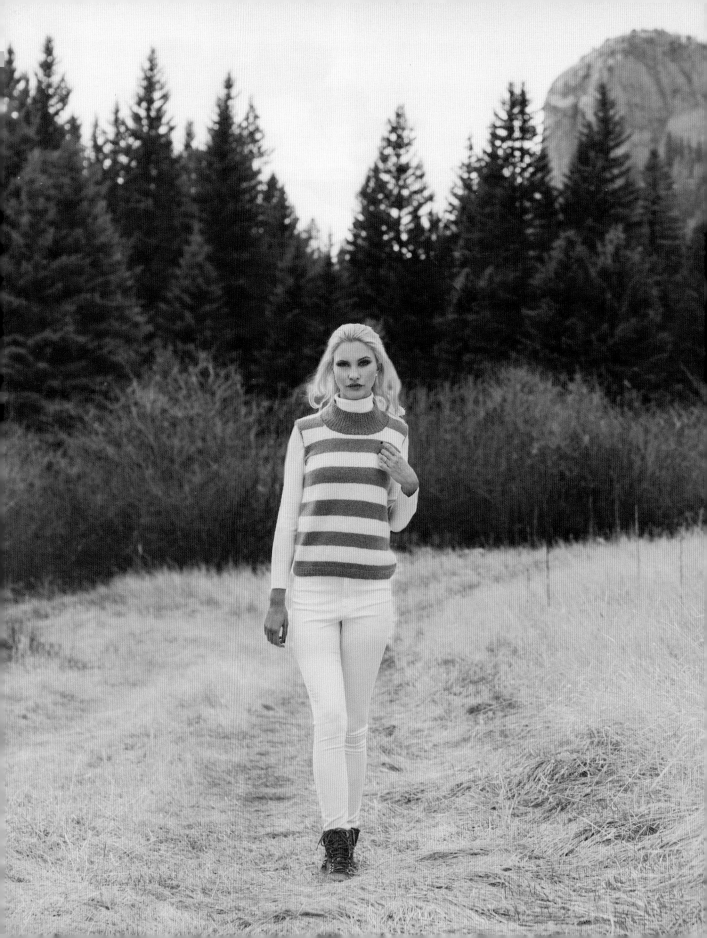

yarmouth

As seasons change, a chill is on the breeze. An extra layer is just the thing to wear on your midday stroll. This classic, restful vest is worked up in the softest of yarns. It's knit in the round in soothing stockinette stitch, then split at the armholes and worked flat. Shoulders are then seamed, and the collar is picked up and knit in the round—as is the armhole edging—for a clean finish.

FINISHED SIZES

32¾ (36¾, 40¾, 44¾, 48¾, 52¾, 56¾, 60¾)" (83 [93.5, 103.5, 113.5, 124, 134, 144, 154.5] cm) bust circumference and 22½ (23½, 24½, 25½, 26½, 27½, 28½, 29½)" (57 [59.5, 62, 65, 67.5, 70, 72.5, 75] cm) long.

Shown in size 32¾" (83 cm).

YARN

Worsted weight [#4 Medium].

Shown here: Woolfolk Får (100% merino wool; 142 yd [130 m]/1¾ oz [50 g]): White #00 (MC), 3 (3, 4, 4, 4, 5, 5, 5) skeins, Grey #3 (CC), 3 (4, 4, 5, 5, 5, 6, 6) skeins.

NEEDLES

Size U.S. 5 (3.75 mm): 16" and 32" (40 and 80 cm) circular (cir).

Size U.S. 7 (4.5 mm): 32" (80 cm) cir.

Adjust needle sizes if necessary to obtain the correct gauge.

NOTIONS

Stitch markers (m); stitch holders; waste yarn; tapestry needle.

GAUGE

20 sts and 29 rnds = 4" (10 cm) in St st with larger needle.

STITCH GUIDE

Beaded Rib
(multiple of 2 sts)

Rnd 1: *K1, p1; rep from * to end of rnd.

Rnd 2: Knit.

Rep Rnds 1 and 2 for patt.

Stripe Pattern
Working in St st, *work 14 rows/rnds with MC, then 14 rows/rnds with CC; rep from * for stripe patt.

Vest

BODY

With longer smaller cir needle and CC, CO 160 (180, 200, 220, 240, 260, 280, 300) sts using Long Tail method (see Glossary). Place marker (pm) and join for working in rnds, being careful not to twist sts.

Work in Beaded Rib for 1½" (3.8 cm).

Note: If you wish to lengthen sweater, either add any additional length to the rib or work an additional 1–2" (2.5–5 cm) in Stripe Patt prior to starting armhole shaping.

Change to larger cir needle.

Inc rnd: *K40 (45, 50, 55, 60, 65, 70, 75), M1; rep from * 3 more times—164 (184, 204, 224, 244, 264, 284, 304) sts.

Next rnd: K82 (92, 102, 112, 122, 132, 142, 152), pm, knit to end.

Work even in St st (knit every rnd) with CC until piece measures 2" (5 cm) from beg. Cont in Stripe Patt throughout.

At the same time, when piece measures 15¼ (15¾, 16¼, 16¾, 17¼, 17¾, 18¼, 18¾)" (38.5 [40, 41.5, 42.5, 44, 45, 46.5, 47.5] cm) from beg, ending last rnd 2 (4, 5, 6, 7, 8, 9, 10) sts before end of rnd. End with an even number of rnds of the last color used.

DIVIDE FRONT AND BACK

Next rnd: BO 4 (8, 10, 12, 14, 16, 18, 20) sts for armhole, work to 2 (4, 5, 6, 7, 8, 9, 10) sts before m, BO 4 (8, 10, 12, 14, 16, 18, 20) sts for armhole, then work to end—78 (84, 92, 100, 108, 116, 124, 132) sts rem each for front and back.

Place front sts on waste yarn.

BACK
Armhole shaping

BO 2 (2, 2, 2, 2, 3, 3, 4) sts at beg of next 4 rows—70 (76, 84, 92, 100, 104, 112, 116) sts rem.

Dec row: (WS) P2, p2tog, purl to last 4 sts, ssp, p2—2 sts dec'd.

Rep Dec row every WS row 0 (1, 4, 6, 9, 9, 11, 12) more time(s)—68 (72, 74, 78, 80, 84, 88, 90) sts rem.

Cont in St st (knit RS rows, purl WS rows) until armhole measures 6½ (7, 7½, 8, 8½, 9, 9½, 10)" (16.5 [18, 19, 20.5, 21.5, 23, 24, 25.5] cm), ending with a RS row.

Shape shoulders

Short-row 1: (WS) Purl to last 5 (6, 7, 7, 7, 8, 8, 8) sts, w&t.

Short-row 2: (RS) Knit to last 5 (6, 7, 7, 7, 8, 8, 8) sts, w&t.

Short-row 3: Purl to 6 (6, 6, 7, 7, 7, 8, 8) sts before last turn, w&t.

Short-row 4: Knit to 6 (6, 6, 7, 7, 7, 8, 8) sts before last turn, w&t.

Short-row 5: Purl to end, picking up wraps and working them tog with the sts they wrap.

Next row: K17 (18, 19, 20, 21, 22, 23, 24) sts, BO 34 (36, 36, 38, 38, 40, 42, 42) sts for neck, knit to end of row, picking up rem wrap and working it tog with the st it wraps—17 (18, 19, 20, 21, 22, 23, 24) sts rem for each shoulder. Place sts on holders.

FRONT

Return held 78 (84, 92, 100, 108, 116, 124, 132) front sts to larger cir needle. Join yarn to beg with a WS row. Pm each side of center 12 sts for neck.

Shape armholes

BO 2 (2, 2, 2, 2, 3, 3, 4) sts at beg of next 4 rows—70 (76, 84, 92, 100, 104, 112, 116) sts rem.

Dec row: (WS) P2, p2tog, purl to last 4 sts, ssp, p2—2 sts dec'd.

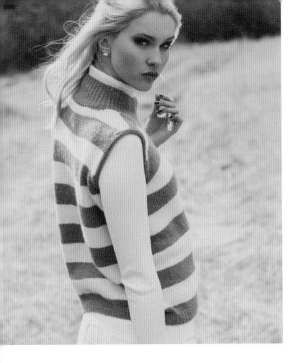

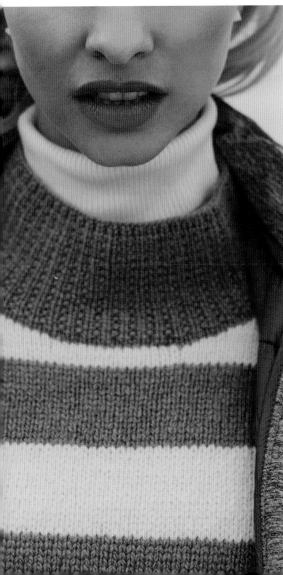

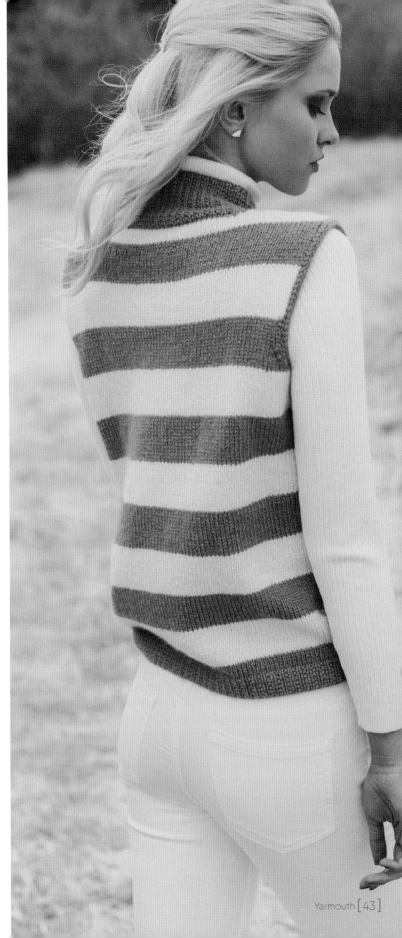

Rep Dec row every WS row 0 (1, 4, 6, 9, 9, 11, 12] more time(s)—68 (72, 74, 78, 80, 84, 88, 90) sts rem.

Shape Neck

Work even until armhole measures 3¼ (3½, 3¾, 4, 4¼, 4½, 4¾, 5)" (8.5 [9, 9.5, 10, 11, 11.5, 12, 12.5] cm), ending with a WS row.

Next row: (RS) Knit to m, BO center 12 marked sts for neck, then knit to end—28 (30, 31, 33, 34, 36, 38, 39) sts rem each side.

Right Shoulder

Work 1 WS row even.

BO at beg of RS rows 4 sts once, 3 sts once, then 2 sts once—19 (21, 22, 24, 25, 27, 29, 30) sts rem.

Work 1 WS row even.

Dec row: (RS) K2, k2tog, knit to end—1 st dec'd.

Rep Dec row 1 (2, 2, 3, 3, 4, 5, 5] more time(s)—17 (18, 19, 20, 21, 22, 23, 24) sts rem.

Cont even until armhole measures 6½ (7, 7½, 8, 8½, 9, 9½, 10)" (16.5 [18, 19, 20.5, 21.5, 23, 24, 25.5] cm), ending with a WS row.

Shape Shoulder

Short-row 1: (RS) Knit to last 5 (6, 7, 7, 7, 8, 8, 8) sts, w&t.

Short-row 2: (WS) Purl to end of row.

Short-row 3: Knit to 6 (6, 6, 7, 7, 7, 8, 8] sts before last turn, w&t.

Short-row 4: Purl to end.

Next row: (RS) Knit all sts, picking up wraps and working them tog with the sts they wrap. Place sts on holder.

Left Shoulder

Rejoin yarn to beg with a WS row.

BO at beg of WS rows 4 sts once, 3 sts once, then 2 sts once—19 (21, 22, 24, 25, 27, 29, 30) sts rem.

Work 1 RS row even.

Dec row: (WS) P2, p2tog, work to end—1 st dec'd.

Rep Dec row 1 (2, 2, 3, 3, 4, 5, 5) more time(s)—17 (18, 19, 20, 21, 22, 23, 24) sts rem.

Cont even until armhole measures 6½ (7, 7½, 8, 8½, 9, 9½, 10)" (16.5 [18, 19, 20.5, 21.5, 23, 24, 25.5] cm), ending with a RS row.

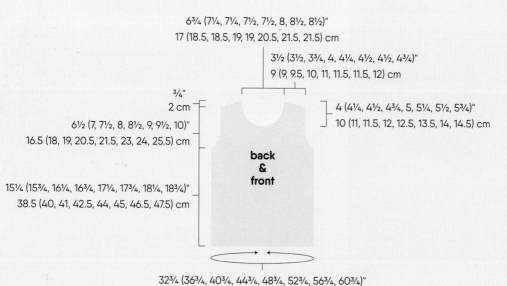

6¾ (7¼, 7¼, 7½, 7½, 8, 8½, 8½)"
17 (18.5, 18.5, 19, 19, 20.5, 21.5, 21.5) cm

3½ (3½, 3¾, 4, 4¼, 4½, 4½, 4¾)"
9 (9, 9.5, 10, 11, 11.5, 11.5, 12) cm

¾"
2 cm

6½ (7, 7½, 8, 8½, 9, 9½, 10)"
16.5 (18, 19, 20.5, 21.5, 23, 24, 25.5) cm

4 (4¼, 4½, 4¾, 5, 5¼, 5½, 5¾)"
10 (11, 11.5, 12, 12.5, 13.5, 14, 14.5) cm

back
&
front

15¼ (15¾, 16¼, 16¾, 17¼, 17¾, 18¼, 18¾)"
38.5 (40, 41, 42.5, 44, 45, 46.5, 47.5) cm

32¾ (36¾, 40¾, 44¾, 48¾, 52¾, 56¾, 60¾)"
83 (93.5, 103.5, 113.5, 124, 134, 144, 154.5) cm

Shoulder shaping

Short-row 1: (WS) Purl to last 5 (6, 7, 7, 7, 8, 8, 8] sts, w&t.

Short-row 2: (RS): Knit to end of row.

Short-row 3: Purl to 6 (6, 6, 7, 7, 7, 8, 8) sts before last turn, w&t.

Short-row 4: Knit to end.

Next row: (WS) Purl all sts, picking up wraps and working them tog with the sts they wrap. Place sts on holder.

Graft shoulders tog (see Glossary).

COLLAR

With smaller, shorter cir needle and CC, pick up and knit 68 (72, 76, 80, 80, 84, 88, 92) sts along front neck edge and 34 (36, 36, 38, 38, 40, 42, 42) sts along back neck edge—102 (108, 112, 118, 118, 124, 130, 134) sts. Pm for beg of rnd and join for working in the rnd.

Work in Beaded Rib for 3" (7.5 cm). BO all sts in patt.

ARMHOLES

With smaller, shorter cir needle and CC, beg at center of underarm BO, pick up and knit 4 (6, 7, 8, 9, 11, 12, 14) sts along BO edge, 75 (76, 79, 82, 85, 86, 89, 90) sts evenly spaced along armhole edge (approximately 3 sts for every 4 rows), then 4 (6, 7, 8, 9, 11, 12, 14) sts along rem BO edge—83 (88, 93, 98, 103, 108, 113, 118) sts. Pm and join for working in the rnd.

CO 3 sts onto LH needle using Backward Loop method (see Glossary).

Use I-cord BO (see Glossary) to BO all sts.

Finishing

Weave in ends. Block to finished measurements.

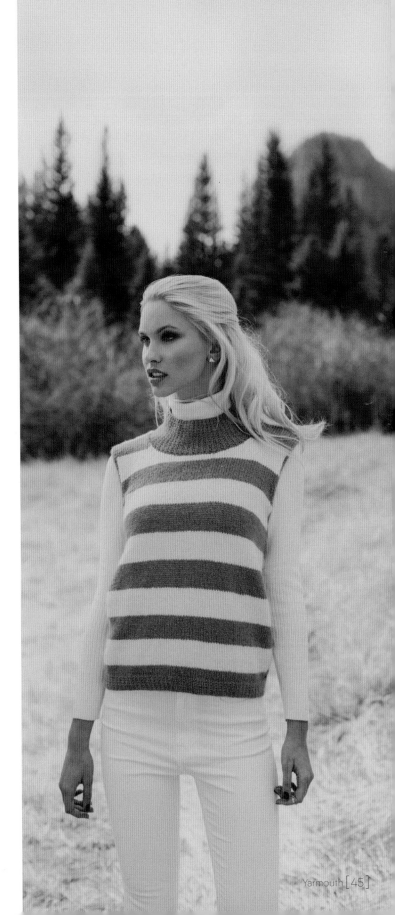

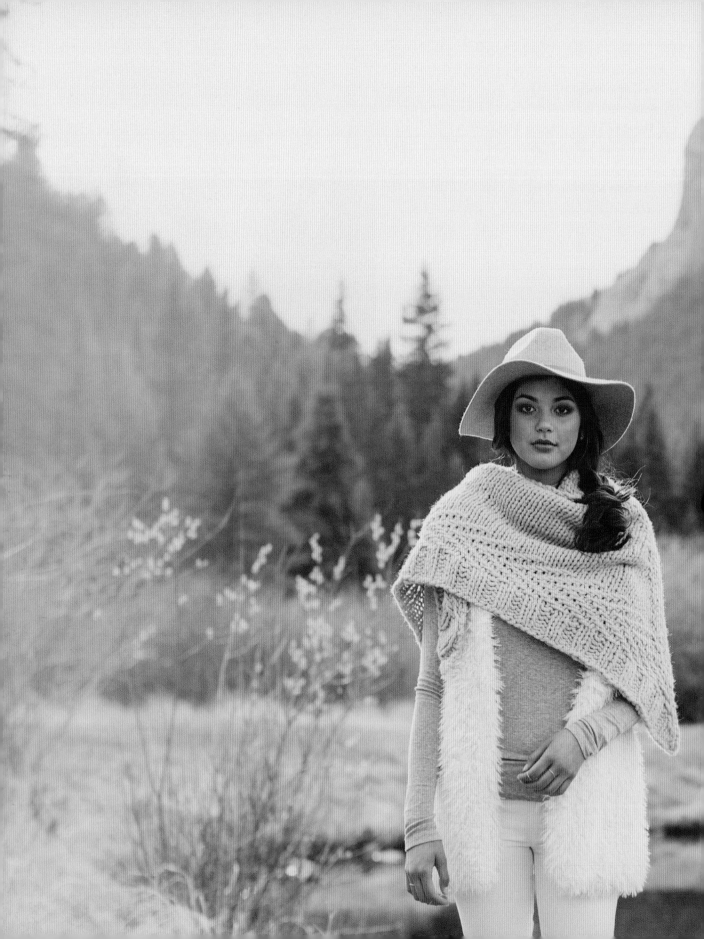

Camden

The air is crisp and clear. Each breeze rustles the faded leaves from their branches on the silver birch. The Camden shawl is the coziest piece possible for afternoon adventures. Thick, excessively squishy and cozy, it is comfort embodied. Camden is worked from the top down, beginning with a garter tab panel.

FINISHED SIZE

63" (160 cm) wide and 31" (78.5 cm) long.

YARN

Bulky [#6 Super Bulky].

Shown in: Woolfolk Hygge (50% merino wool, 28% alpaca, 22% silk; 76 yd [69 m]/3½ oz [100 g]): #2 silver grey, 5 skeins.

NEEDLES

Size U.S. 17 (12.75 mm): 32" (80 cm) circular (cir).

Adjust needle size if necessary to obtain the correct gauge.

NOTIONS

Stitch markers (m); tapestry needle.

GAUGE

7 sts and 12 rows = 4" (10 cm) in St st.

NOTES

— When picking up sts along the side of the foundation tab, pick up and knit each st using only one leg of the outer stitch to compensate for the super bulky nature of the yarn.

— When working the chart, slip sts and yo's are going to be worked next to each other on all RS rows. To ensure these are worked correctly on the WS, at the beg of the section, yo knitwise and bring yarn to the front between needles before slipping the next stitches; at the end of the section, slip the stitches with the yarn in front, then bring the yarn to the back between the needles, then around the needle to yo.

Shawl

CO 2 sts using Backward Loop method (see Glossary). Work 10 rows in Garter st (knit every row).

Next row: (RS) K2, rotate piece 90 degrees to the right, pick up and knit 5 sts along side edge, rotate piece 90 degrees to the right, then pick up and knit 2 sts in CO edge—9 sts.

Set-up row: (WS) K1, place marker (pm), p3, pm, p1, pm, p3, pm, k1.

INCREASE SECTION

Inc row: (RS) K1, [sm, yo, knit to m, yo, sm, k1] twice—4 sts inc'd.

Next row: (WS) K1, sm, p1-tbl, purl to 1 st before m, p1-tbl, sm, p1, sm, p1-tbl, purl to 1 st before m, p1-tbl, sm, k1.

Rep last 2 rows 23 times more—105 sts.

Inc row: (RS) K1, sm, knit to m, yo, sm, k1, sm, yo, knit to end—107 sts.

Next row: (WS) K1, sm, purl to 1 st before m, p1-tbl, sm, p1, sm, p1-tbl, purl to m, sm, k1.

HERRINGBONE SECTION

Inc row: (RS) K1, sm, work row 1 of chart to m, sm, k1, sm, work row 1 of chart to m, sm, k1—4 sts inc'd.

Next row: (WS) K1, sm, work row 2 of chart to m, sm, p1, sm, work Row 2 of chart to m, sm, p1.

Work Rows 3–16 of chart as established—139 sts.

RIB SECTION

Inc row 1: (RS) K1, sm, yo, [k2, p2] to m, yo, sm, k1, sm, yo, [p2, k2] to m, yo, sm, k1—143 sts.

Next row: (WS) K1, sm, k1-tbl, [p2, k2] to 1 st before m, p1-tbl, sm, p1, sm, p1-tbl, [k2, p2] to 1 st before m, k1-tbl, sm, k1.

Inc row 2: K1, sm, yo, p1, [k2, p2] to 1 st before m, k1, yo, sm, k1, sm, yo, k1, [p2, k2] to 1 st before m, p1, yo, sm, k1—147 sts.

Next row: K1, sm, k1-tbl, k1, [p2, k2] to 2 sts before m, p1, p1-tbl, sm, p1, sm, p1-tbl, p1, [k2, p2] to 2 sts before m, k1, k1-tbl, sm, k1.

Inc row 3: K1, sm, yo, [p2, k2] to m, yo, sm, k1, sm, yo, [k2, p2] to m, yo, sm, k1—151 sts.

Next row: K1, sm, p1-tbl, [k2, p2] to 1 st before m, k1-tbl, sm, p1, sm, k1-tbl, [p2, k2] to 1 st before m, p1-tbl, k1.

BO all sts loosely in established rib.

Finishing

Weave in ends. Block to measurements.

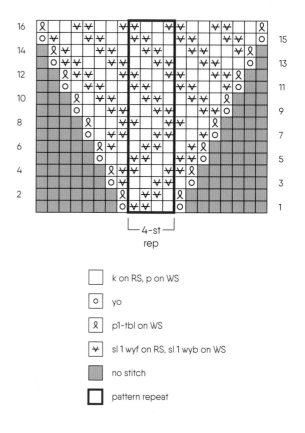

4-st rep

	k on RS, p on WS
o	yo
ᚋ	p1-tbl on WS
⌄	sl 1 wyf on RS, sl 1 wyb on WS
	no stitch
	pattern repeat

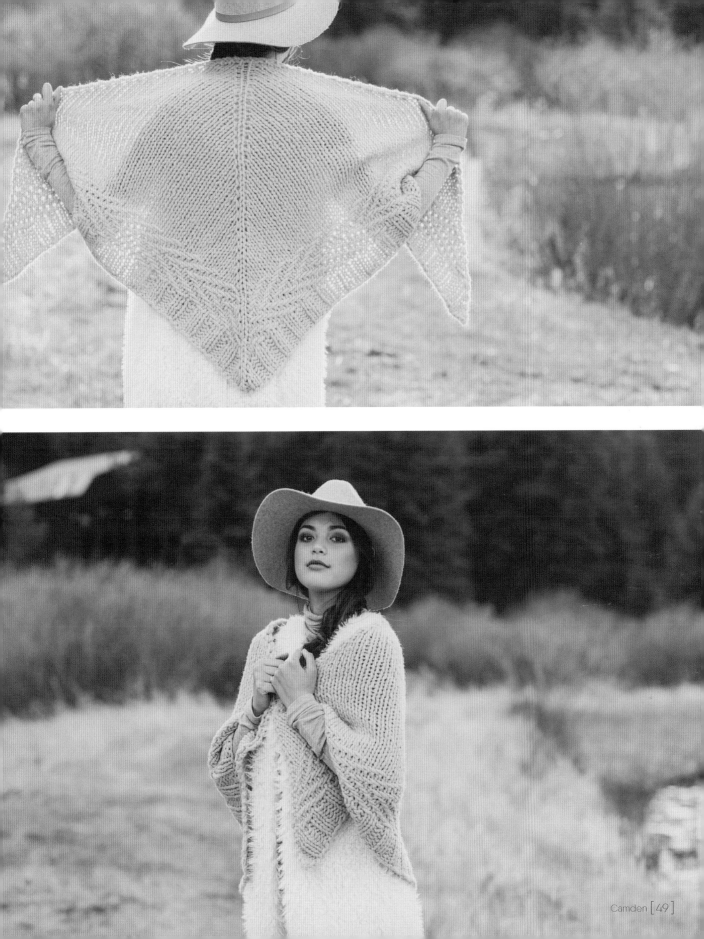

Delafield

The trees beckon you to walk the hidden path, where the breeze will gently kiss your cheek and dappled sunlight will warm and calm your spirit. Showcasing a smooth mohair-merino blend, a single, prominent cable grows up one side of this wrap as it is worked from the bottom up.

FINISHED SIZE

53" (134.5 cm) long and 15" (38 cm) wide.

YARN

Bulky weight [#6 Super Bulky].

Shown here: Quince & Co. Ibis (50% Texas super kid mohair, 50% Texas superfine merino wool; 96 yd [88 m]/3½ oz [100 g]): Abilene, 4 skeins.

NEEDLES

Size U.S. 13 (9 mm): 16" (40 cm) circular (cir).

Adjust needle size if necessary to obtain the correct gauge.

NOTIONS

Stitch markers (m); cable needle (cn); tapestry needle.

GAUGE

10 sts and 13 rows = 4" (10 cm) in St st.

16-st Cable Panel = approximately 4¾" (12 cm) wide.

NOTES

— A circular needle is used to accommodate the width of the wrap. Do not join; work back and forth.

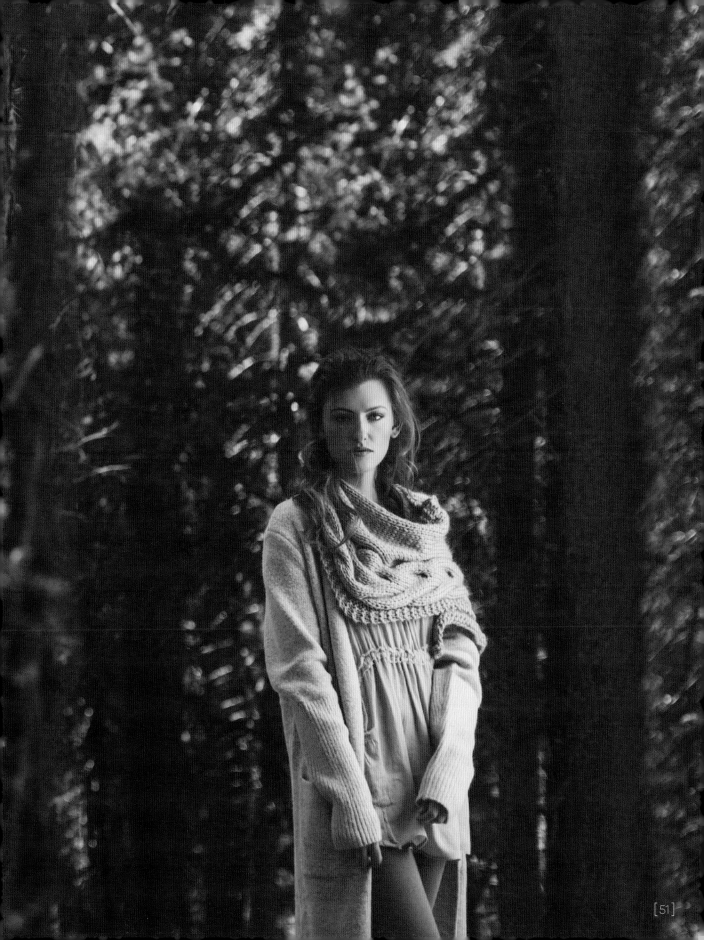

STITCH GUIDE

4/4 LC (4 over 4 left cross): Sl 4 sts onto cn and hold to front of work, k4, k4 from cn.

4/4 RC (4 over 4 right cross): Sl 4 sts onto cn and hold to back of work, k4, k4 from cn.

Cable Panel

(panel of 16 sts)

Row 1 and all other WS rows: P16.

Rows 2, 6, and 8: K16.

Row 4: 4/4 LC, k8.

Row 10: K8, 4/4 RC.

Row 12: Knit.

Rep Rows 1–12 for Cable Panel.

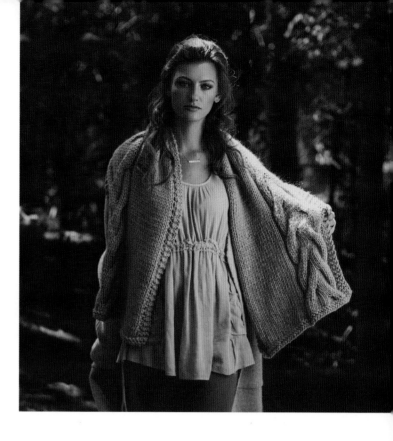

Wrap

CO 46 sts using Long Tail method (see Glossary). Do not join.

Knit 3 rows.

Set-up row: (RS) K3, p2, place marker (pm), k16, pm, p2, k23.

BODY

Row 1: (WS) K3, p20, k2, sm, work Row 1 of Cable Panel (see Stitch Guide or chart) over next 16 sts, sm, k5.

Rows 2, 6, and 8: (RS) K3, p2, sm, work next row of Cable Panel over next 16 sts, sm, p2, k19, yo, k2tog, k2.

Row 3 and all other WS rows: K3, p20, k2, sm, work next row of Cable Panel over next 16 sts, sm, k5.

Row 4: K3, p2, sm, work Row 4 of Cable Panel over next 16 sts, sm, p2, k19, yo, k2tog, k2.

Row 10: K3, p2, work Row 10 of Cable Panel over next 16 sts, sm, p2, k19, yo, k2tog, k2.

Row 12: Rep Row 2.

Rep Rows 1–12 until piece measures 52" (132 cm) from beg, ending with a WS row.

Knit 4 rows.

BO all sts kwise.

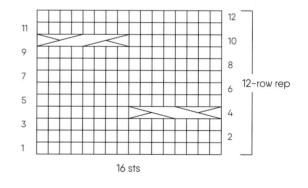

16 sts

12-row rep

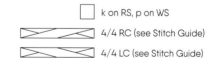

k on RS, p on WS

4/4 RC (see Stitch Guide)

4/4 LC (see Stitch Guide)

Finishing

Weave in ends. Block lightly to measurements.

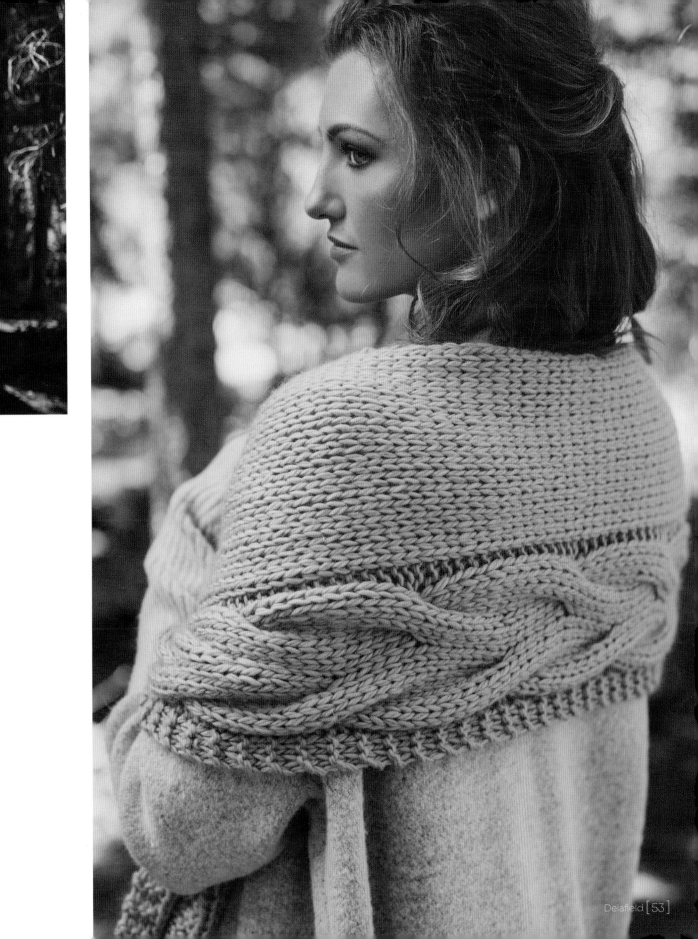

Keene

In the clearing, mist has lifted to reveal untouched beauty. A single fawn lifts its head swiftly, pausing. The Keene pullover is inspired by moments face to face with nature's beauty. This updated classic is perfect for any situation, knit with a plush merino-alpaca blend and featuring a flattering straight silhouette and large fisherman's rib turtleneck. The Keene pullover is worked from the top down, as a raglan.

FINISHED SIZES

33¼ (37, 40½, 44¼, 48, 51¾)" (84.5 [94, 103, 112.5, 122, 131.5] cm) bust circumference and 24½ (25½, 26½, 27½, 28½, 30)" [62 (65, 67.5, 70, 72.5, 76] cm) long.

Shown in size 37" (94 cm).

YARN

Chunky weight [#5 Bulky].

Shown here: Berroco Ultra Alpaca Chunky (50% alpaca, 50% wool; 131 yd [120 m]/3½ oz [100 g]): #7214 Steel Cut Oats 6 (7, 7, 8, 8, 9) skeins.

NEEDLES

Size U.S. 10½ (6.5 mm): 16" and 32" (40 and 80 cm) circular (cir) and set of 4 or 5 double-pointed (dpn).

Size U.S. 11 (8 mm): 16" and 32" (40 and 80 cm) cir and set of 4 or 5 dpn.

Adjust needle size if necessary to obtain the correct gauge.

NOTIONS

Stitch markers (m); waste yarn; tapestry needle.

GAUGE

13 sts and 17 rnds = 4" (10 cm) in St st with larger needles.

NOTES

— This sweater is worked in the round from the top down.

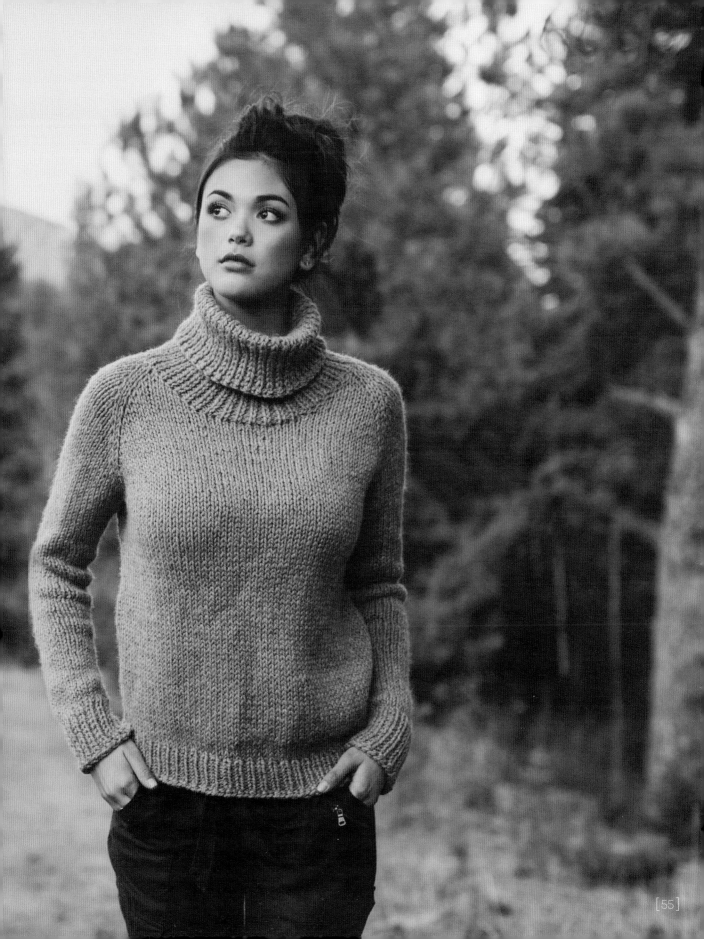

STITCH GUIDE

Fisherman's Rib

(multiple of 2 sts)

Rnd 1: [K1, p1] to end of rnd.

Rnd 2: [Sl 1 wyb, p1] to end of rnd.

Rep Rnds 1 and 2 for patt.

Reverse Fisherman's Rib

Rnd 1: [K1, p1] to end of rnd.

Rnd 2: [K1, sl 1 wyf] to end of rnd.

Rep Rnds 1 and 2 for patt.

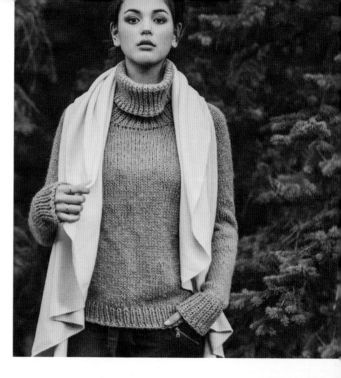

Instructions

YOKE

With shorter, larger cir needle, CO 34 (42, 38, 34, 36, 36) sts using Long Tail method (see Glossary). Do not join.

Set-up row: (RS) K2 for right front, place marker (pm), k4 (6, 4, 2, 2, 2) for sleeve, pm, k22 (26, 26, 26, 28, 28) for back, pm, k4 (6, 4, 2, 2, 2) for sleeve, pm, then k2 for left front.

Next row: (WS) Purl.

Inc row 1: K1, M1R, k1, sm, [k1, M1L, knit to 1 st before m, M1R, k1, sm] 3 times, knit to last st, M1L, k1—42 (50, 46, 42, 44, 44) sts, with 3 sts for each front, 6 (8, 6, 4, 4, 4) sts for each sleeve, and 24 (28, 28, 28, 30, 30) sts for back.

Next row: Purl.

Inc row 2: [K1, M1R, knit to 1 st before m, M1L, k1, sm] 4 times, k1, M1R, knit to last st, M1L, k1—10 sts inc'd.

Rep last 2 rows 3 (4, 5, 5, 6, 6) more times, ending with a RS row—82 (100, 106, 102, 114, 114) sts, with 11 (13, 15, 15, 17, 17) sts for each front, 14 (18, 18, 16, 18, 18) sts for each sleeve, and 32 (38, 40, 40, 44, 44) sts for back. Do not turn at end of last row.

Note: Rnds beg at left front raglan m.

Joining rnd: With RS facing, CO 10 (12, 10, 10, 10, 10) sts for front neck using Backward Loop method (see Glossary),

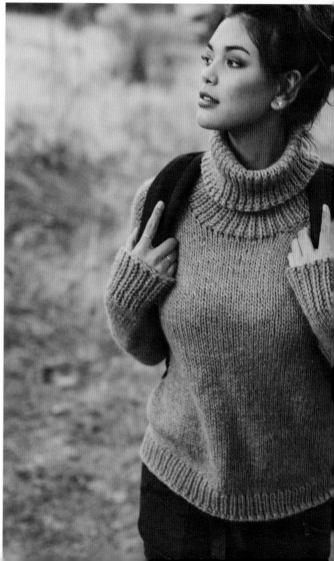

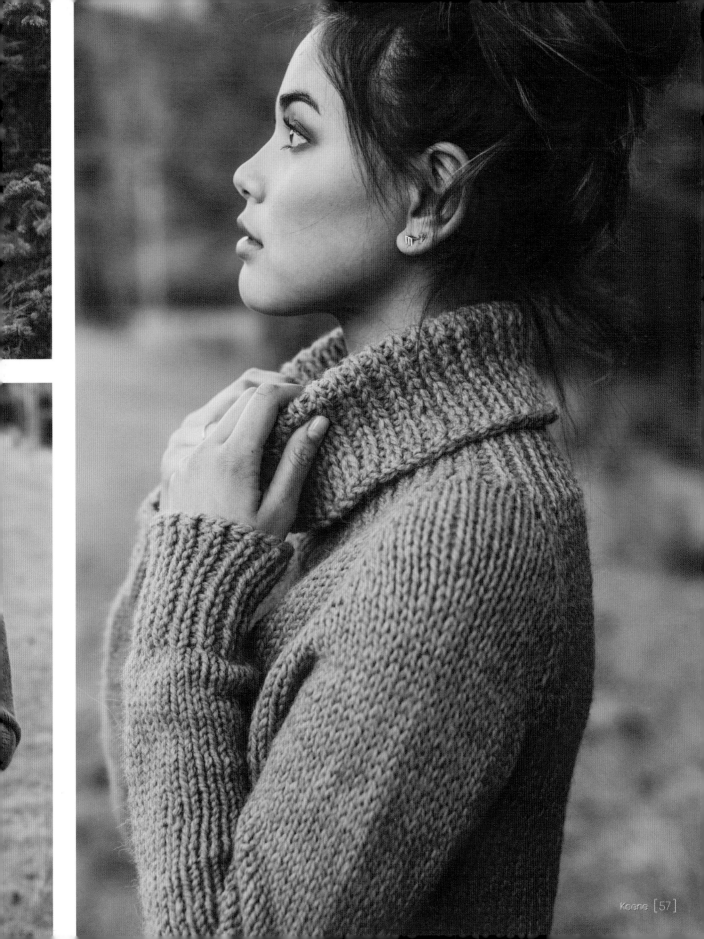

join for working in the rnd, knit to m, sm, knit to end of rnd—92 (112, 116, 112, 124, 124) sts, with 32 (38, 40, 40, 44, 44) sts each for front and back, and 14 (18, 18, 16, 18, 18) sts for each sleeve.

Inc rnd: [K1, M1L, knit to 1 st before m, M1R, k1, sm] 4 times—8 sts inc'd.

Rnd 2: Knit.

Rep last 2 rnds 8 (8, 10, 13, 14, 17) more times—164 (184, 204, 224, 244, 268) sts, with 50 (56, 62, 68, 74, 80) sts each for front and back, and 32 [36, 40, 44, 48, 54] sts for each sleeve.

DIVIDE BODY AND SLEEVES

Next rnd: *Remove m and place 32 (36, 40, 44, 48, 54) sleeve sts on waste yarn, CO 2 sts using Backward Loop method, sm, CO 2*, knit 50 (56, 62, 68, 74, 80) back sts; rep from * to * once, knit 50 (56, 62, 68, 74, 80) front sts—108 (120, 132, 144, 156, 168) sts.

Cont even in St st (knit every rnd) until piece measures 15" (38 cm) from underarm.

Change to longer smaller cir needle. Work in K1, P1 Rib for 2" (5 cm). BO using Jeny's Surprisingly Stretchy BO (see Glossary).

SLEEVES (MAKE 2)

Return held 32 (36, 40, 44, 48, 54) sleeve sts to larger dpn. Distribute sts evenly over 3 or 4 dpn. Beg at center under arm CO, pick up and knit 2 sts, knit sleeve sts, then pick up and knit 2 sts in rem underarm CO—36 (40, 44, 48, 52, 58) sts. Pm and join for working in the rnd.

Work 13 (9, 8, 6, 5, 4) rnds even in St st.

Dec rnd: K1, k2tog, knit to last 3 sts, ssk, k1—2 sts dec'd.

Cont in St st, rep dec rnd every 14 (10, 9, 7, 6, 5] rows 3 (5, 6, 7, 9, 5) more times, then every 0 (0, 0, 0, 0, 4) rnds 0 (0, 0, 0, 0, 7) times—28 [28, 30, 32, 32, 32] sts rem.

Work even until sleeve measures 17 (17, 16½, 16, 15½, 15)" (43 [43, 42, 40.5, 39.5, 38] cm) from underarm.

Change to smaller dpn. Work in Fisherman's Rib (see Stitch Guide) for 4" (10 cm). BO using Jeny's Surprisingly Stretchy BO.

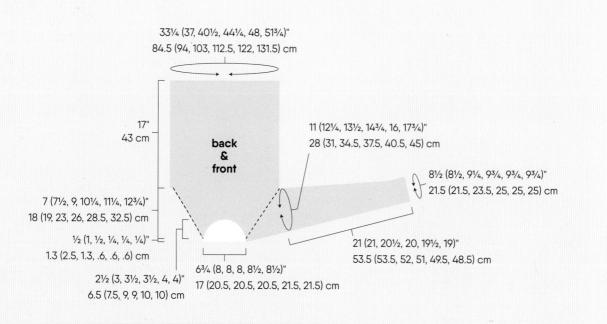

33¼ (37, 40½, 44¼, 48, 51¾)"
84.5 (94, 103, 112.5, 122, 131.5) cm

17"
43 cm

back & front

11 (12¼, 13½, 14¾, 16, 17¾)"
28 (31, 34.5, 37.5, 40.5, 45) cm

8½ (8½, 9¼, 9¾, 9¾, 9¾)"
21.5 (21.5, 23.5, 25, 25, 25) cm

7 (7½, 9, 10¼, 11¼, 12¾)"
18 (19, 23, 26, 28.5, 32.5) cm

½ (1, ½, ¼, ¼, ¼)"
1.3 (2.5, 1.3, .6, .6, .6) cm

2½ (3, 3½, 3½, 4, 4)"
6.5 (7.5, 9, 9, 10, 10) cm

6¾ (8, 8, 8, 8½, 8½)"
17 (20.5, 20.5, 20.5, 21.5, 21.5) cm

21 (21, 20½, 20, 19½, 19)"
53.5 (53.5, 52, 51, 49.5, 48.5) cm

COLLAR

With smaller shorter cir needle and RS facing, pick up and knit 24 (28, 28, 28, 30, 30) sts along back neck, 6 (8, 6, 4, 4, 4) sts along left sleeve, 34 (38, 42, 42, 46, 46) sts along front neck, and 6 (8, 6, 4, 4, 4) sts along right sleeve—70 (82, 82, 78, 84, 84) sts. Pm and join for working in the rnd.

Work in Fisherman's Rib (see Stitch Guide) for 4½" (11.5 cm).

Cont in Reverse Fisherman's Rib (see Stitch Guide) until collar measures 9" (23 cm).

BO all sts using Jeny's Surprisingly Stretchy BO.

Finishing

Weave in ends. Block to measurements.

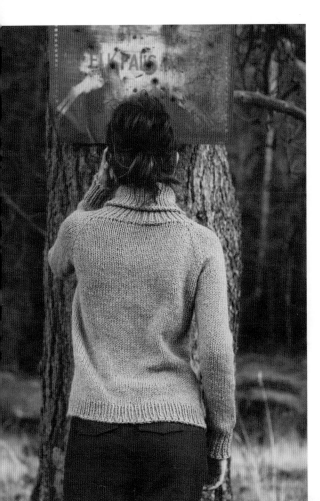

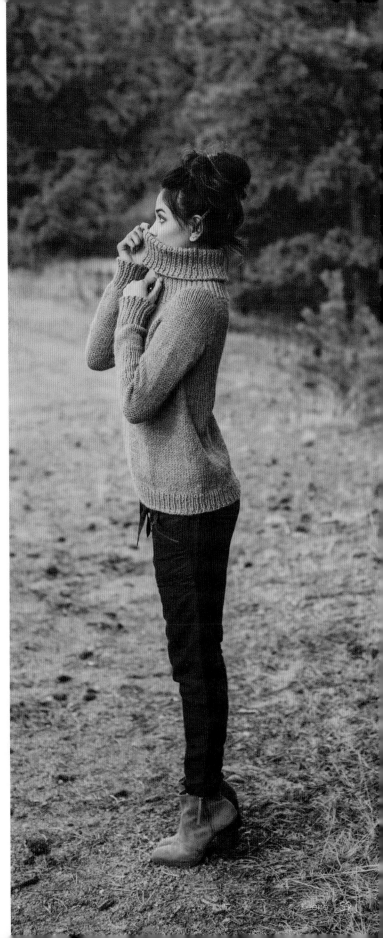

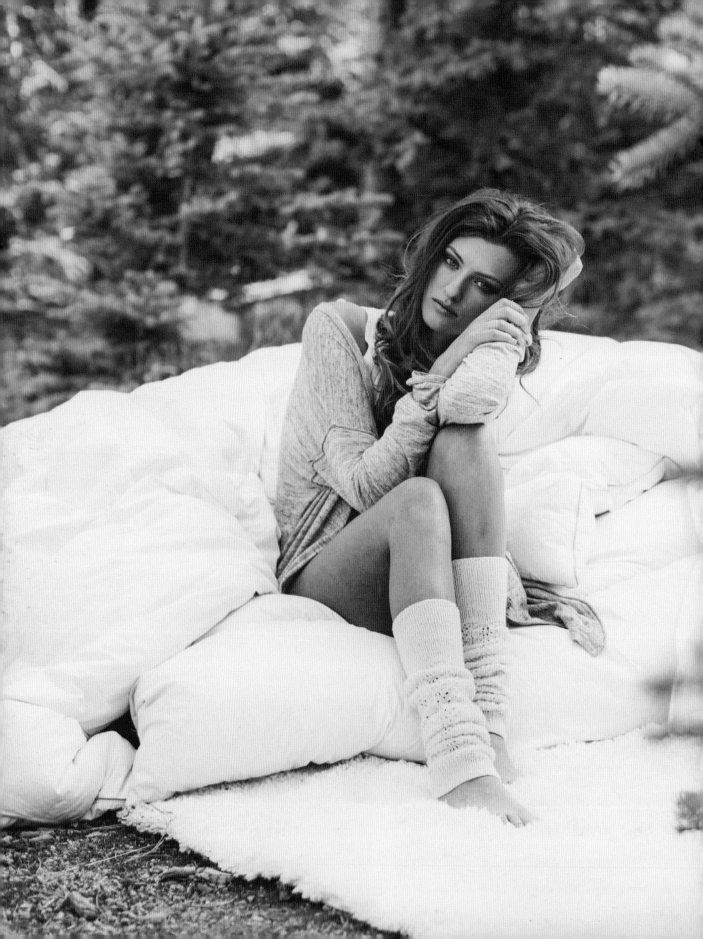

Fennimer

As delicate and light as a fern curling up from the forest floor, beautiful lacework defines these feminine legwarmers. Knit in the round from the top down, they are simple to make in a supple yet strong superwash merino wool.

FINISHED SIZES

8½ (10)" (21.5 [25.5] cm) circumference and 19¾ (21)" (50 [53.5] cm) long.

Sample shown in size 8½" (21.5 cm).

YARN

Sport weight [#2 Fine].

Shown here: Ella Rae Lace Merino (100% superwash merino wool; 460 yd [421 m]/3½ oz [100 g]): #0 Natural, 2 (2) skeins.

NEEDLES

Size U.S. 1 (2.25 mm): set of 4 double-pointed (dpn).

Size U.S. 3 (3.25 mm): set of 4 dpn.

Adjust needle sizes if necessary to obtain the correct gauge.

NOTIONS

Stitch marker (m); tapestry needle.

GAUGE

39½ sts and 37 rnds = 4" (10 cm) in Lace Patt with larger needles.

NOTES

— The leg warmers are worked from the top down.

Lace Pattern

(multiple of 14 sts)

Rnds 1 and 2: *K1-tbl, k13; rep from * around.

Rnd 3: *K1-tbl, k4tog, [yo, k1] 5 times, yo, k4tog tbl; rep from * around.

Rnd 4: Rep Rnd 1.

Rep Rnds 1–4 for patt.

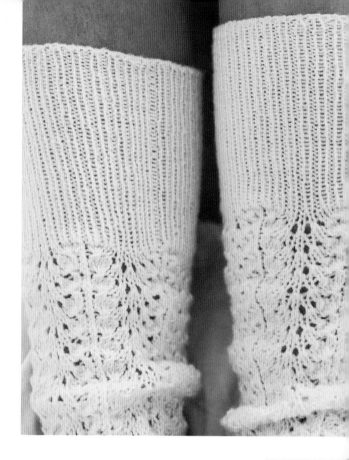

Leg Warmers

(Make 2)

With smaller dpn, CO 84 (98) sts. Distribute sts evenly over 3 dpn with 28 (35) sts on first 2 dpn, and 28 sts on 3rd dpn. Place marker (pm) and join for working in rnds, being careful not to twist sts.

Next rnd: *K1, p1; rep from * to end of rnd.

Rep last rnd until ribbing measures 4¾" (12 cm) from beg.

Change to larger dpn.

Work Rnds 1–4 of Lace Patt (see Stitch Guide or chart) until 16 (17) rep have been worked, ending with Rnd 4 of patt. Piece should measure approximately 11¾ (12¼)" (30 [31] cm) from beg.

Change to smaller dpn.

Cont in established patt until 14 (16) more rep have been worked, ending with Rnd 4 of patt. Piece should measure approximately 17¾ (19)" (45 [48.5] cm) from beg.

Work in k1, p1 ribbing for 2" (5 cm).

BO all sts loosely in rib.

Finishing

Weave in ends. Block lightly to measurements.

3

1

14-st rep

☐ knit ⟋ k4tog

Ջ k1-tbl ⅄ k4tog tbl

○ yo ☐ pattern repeat

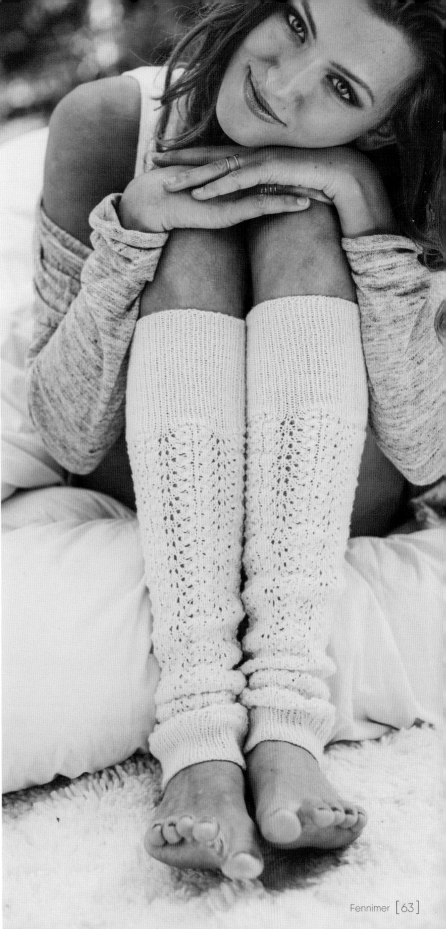

Cape Elizabeth

Scattered eyelets are reminiscent of sunlight breaking through the wooded canopy of trees. A simple, linear lace at the edges mimics the numerous tassels of a pine tree. Shades of fawn, olive, and evergreen blend together harmoniously. Cape Elizabeth is worked flat in one piece, then seamed across the top edge to form a cape.

FINISHED SIZE

55" (139.5 cm) wide and 15¾" (40 cm) long, before seaming.

YARN

Worsted Weight [#4 medium].

Shown here: Nice & Knit Worsted (100% merino wool; 218 yd [199 m]/3½ oz [100 g]): Oyster, 4 skeins.

NEEDLES

Size U.S. 6 (4 mm): 24" or longer circular (cir).

Size U.S. 8 (5 mm): 24" or longer cir.

Adjust needle size if necessary to obtain the correct gauge.

NOTIONS

Stitch markers (m); tapestry needle.

GAUGE

18½ sts and 26 rows = 4" (10 cm) in St st with larger needles.

NOTES

— Wrap is knit flat, then seamed along the edge opposite the Arrowhead Lace, leaving an opening for the neck

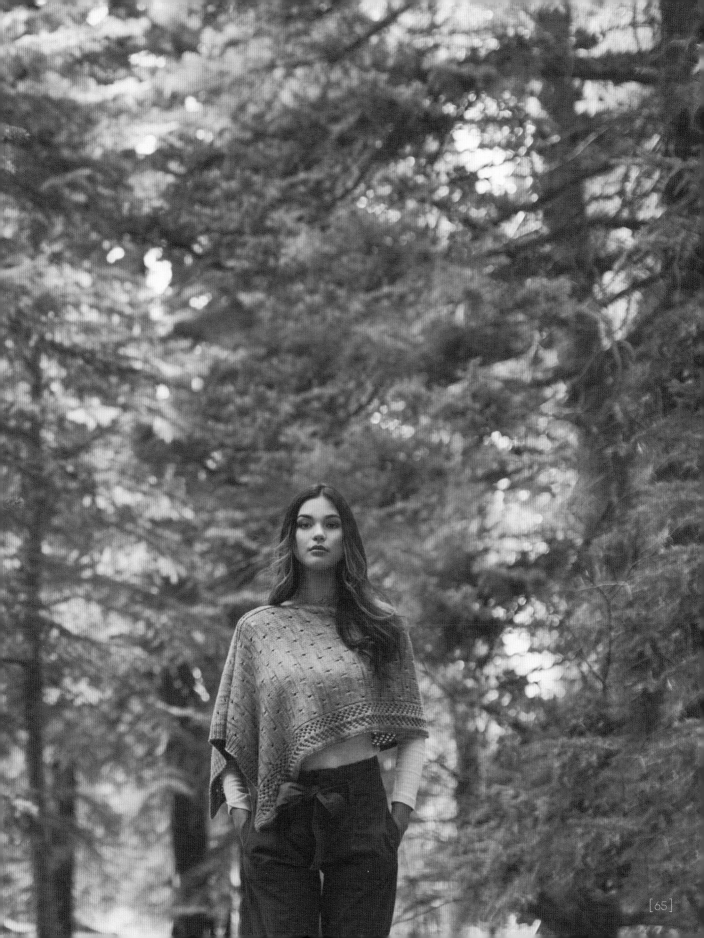

STITCH GUIDE

Arrowhead Lace
(panel of 11 sts)

Row 1: (RS) K1, [yo, ssk] twice, k1, [k2tog, yo] twice, k1.

Rows 2 and 4: (WS) Purl.

Row 3: K2, yo, ssk, yo, sk2p, yo, k2tog, yo, k2.

Rep Rows 1–4 for patt.

Eyelet Pattern
(multiple of 8 sts)

Rows 1, 3, 7, 9, 11, and 15: (RS) Knit.

Row 2 and all other WS rows: Purl.

Row 5: *K2, yo, k2tog, k4; rep from * to end.

Row 13: *K6, yo, k2tog; rep from * to end.

Rep Rows 1–16 for patt.

Row 16: Purl.

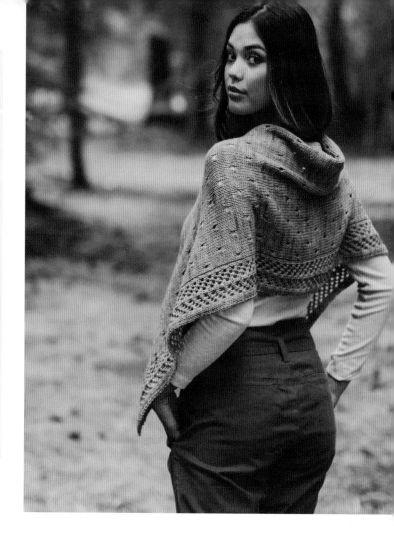

Wrap

With smaller needles, CO 75 sts.

Row 1: (RS) [P1, k1] to last st, p1.

Row 2: (WS) [K1, p1] to last st, k1.

Rep last 2 rows until rib measures 2" (5 cm), ending with a RS row.

Change to larger needles.

Set-up row: (WS) [K1, p1] twice, place marker (pm), p11, pm, k1, pm, p28, m1p, p28, pm, [k1, p1] twice—76 sts.

BODY

Next row: (RS) [P1, k1] twice, sm, work Row 1 of Eyelet Patt (see Stitch Guide) to m, sm, p1, sm, work Row 1 of Arrowhead Lace (see Stitch Guide) over next 11 sts, sm, [k1, p1] twice.

Next row: (WS) [K1, p1] twice, sm, work Row 2 of Arrowhead Lace over next 11 sts, sm, k1, sm, work Row 2 of Eyelet Patt to m, sm, [k1, p1] twice.

Cont in established patt until piece measures 53" (134.5 cm) from beg, ending with a Row 6 or 14 of Eyelet Patt, and dec 1 st at center of Eyelet Patt on last row—75 sts rem.

Change to smaller needles.

Next row: (RS) [P1, k1] to last st, p1.

Cont in established ribbing for 2" (5 cm).

BO all sts loosely in rib.

Finishing

Weave in ends. Block to finished measurements.

Fold piece in half lengthwise with RS together (WS is facing). Starting at the open edge, sew along edge without the Arrowhead Lace pattern for approximately 15½" (39.5 cm), leaving 12" (30.5 cm) open for neck. Make sure the edge with the Arrowhead Lace panel is at the bottom of the wrap.

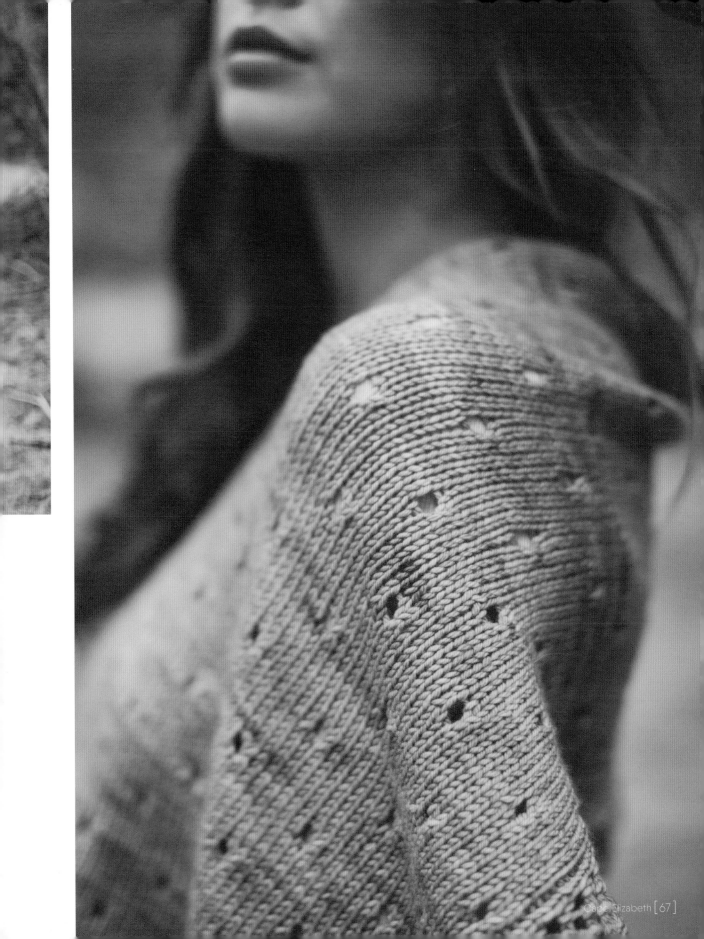

Langlade

Sometimes the greatest joys can be found in the smallest details. This pullover, worked from the top down, features soothing stockinette stitches with a hint of delicate lace detail traveling down the sleeves.

FINISHED SIZES

31 (34¾, 38¼, 41¾, 45¼, 49, 52½, 56)" (78.5 [88.5, 97, 106, 115, 124.5, 133.5, 142] cm) bust circumference and 26¼ (27¼, 28¼, 29, 30, 31, 32, 32¾)" (66.5 [69, 72, 73.5, 76, 78.5, 81.5, 83] cm) long.

Shown in size 34¾" (88.5 cm).

YARN

Worsted weight [#4 Medium].

Shown here: Dragonfly Fibers Valkyrie (100% superwash merino wool; 200 yd [183 m]/3½ oz [100 g]): Silver Fox, 4 (5, 5, 6, 6, 7, 7, 8) skeins.

NEEDLES

Size U.S. 6 (4 mm): 16" and 32" (40 and 80 cm) circular (cir), and set of 4 or 5 double-pointed (dpn).

Size U.S. 8 (5 mm): 16" and 32" (40 and 80 cm) cir, and set of 4 or 5 dpn.

Adjust needle sizes if necessary to obtain the correct gauge.

NOTIONS

Stitch markers (m) in two unique colors; waste yarn; tapestry needle.

GAUGE

18 sts and 27 rnds = 4" (10 cm) in St st with larger needles.

NOTES

— This sweater is worked in the round from the top down with raglan shaping.

— To make it easier to work the lace panels and raglan shaping, use two uniquely colored markers, one color for the lace panels and the second color for the raglans.

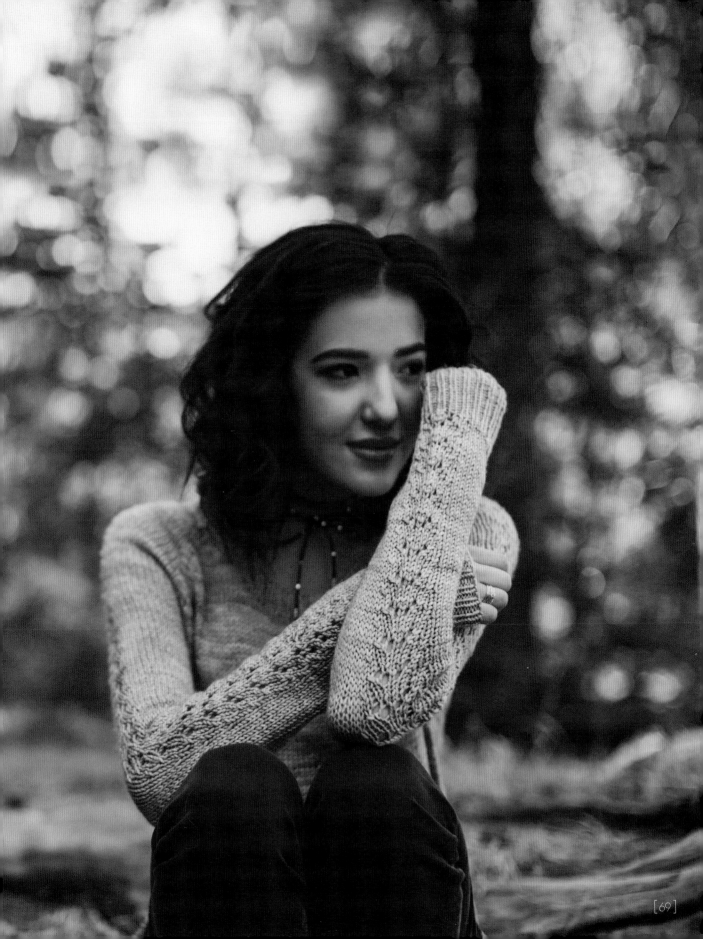

STITCH GUIDE

Lace Panel (worked in rows)
(panel of 9 sts)

Row 1: (RS) K9.

Row 2 and all WS rows: P9.

Row 3: K2tog, k2, yo, k1, yo, k2, skp.

Row 5: K1, k2tog, yo, k3, yo, skp, k1.

Row 6: P9.

Rep Rows 1–6 for Lace Panel worked in rows.

Lace Panel (worked in the round)
(panel of 9 sts)

Rnds 1 and 2: K9.

Rnd 3: K2tog, k2, yo, k1, yo, k2, skp.

Rnd 4: K9.

Rnd 5: K1, k2tog, yo, k3, yo, skp, k1.

Rnd 6: K9.

Rep Rnds 1–6 for Lace Panel worked in the rnd.

Inc row 2: (body and sleeves) K1f&b, k1, sm, k1, M1L, knit to m, sm, work next row of Lace Panel, sm, knit to 1 st before m, M1R, k1, sm, k1, M1L, knit to 1 st before next m, M1R, k1, sm, k1, M1L, knit to m, sm, work next row of Lace Panel, sm, knit to 1 st before m, M1R, k1, sm, k1, k1f&b—94 (96, 98, 100, 102, 104, 106, 108) sts, with 3 sts for each front, 27 sts for each sleeve, and 34 (36, 38, 40, 42, 44, 46, 48) sts for back.

Next row: Purl, working next row of Lace Panel between lace m.

SHAPE NECKLINE AND YOKE

Inc row 3: (body only, RS) [K1, M1L, knit to 1 st before m, M1R, k1, sm, work to next raglan m, sm] 2 times, k1, M1L, knit to last st, M1R, k1—6 sts inc'd.

Next row: Purl, working next row of Lace Panel between lace m.

Inc row 4: (body and sleeves, RS) K1, M1L, [knit to 1 st before m, M1R, k1, sm, k1, M1L, work to 1 st before next raglan m, M1R, k1, sm, k1, M1L] 2 times, sm, knit to last st, M1R, k1—10 sts inc'd.

Next row: Purl, working next row of Lace Panel between lace m.

Pullover

YOKE

With shorter larger cir needle, CO 82 (84, 86, 88, 90, 92, 94, 96) sts using Long Tail method (see Glossary). Do not join.

Set-up row: (WS) P1, place marker (pm) for raglan, p8, pm for Lace Panel, p9, pm for Lace Panel, p8, pm for raglan, p30 (32, 34, 36, 38, 40, 42, 44) for back, pm for raglan, p8, pm for Lace Panel, p9, pm for Lace Panel, p8, pm for raglan, p1.

Inc row 1: (body only, RS) K1f&b, sm, k8, sm, work Row 1 of Lace Panel (see Stitch Guide or chart) over next 9 sts, sm, k8, sm, k1, M1L, knit to 1 st before next marker, M1R, k1, sm, k8, sm, work row 1 of Lace Panel over next 9 sts, sm, k8, sm, k1f&b—86 (88, 90, 92, 94, 96, 98, 100) sts, with 2 sts for each front, 25 sts for each sleeve, and 32 (34, 36, 38, 40, 42, 44, 46) sts for back.

Next row: (WS) Purl, working Row 2 of Lace Panel between lace m.

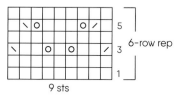

9 sts

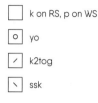

k on RS, p on WS

o — yo

/ — k2tog

\ — ssk

Note: *When working in the rnd, read all chart rows from right to left. When working back and forth, read odd-numbered (RS) rows from right to left, and even-numbered (WS) rows from left to right.*

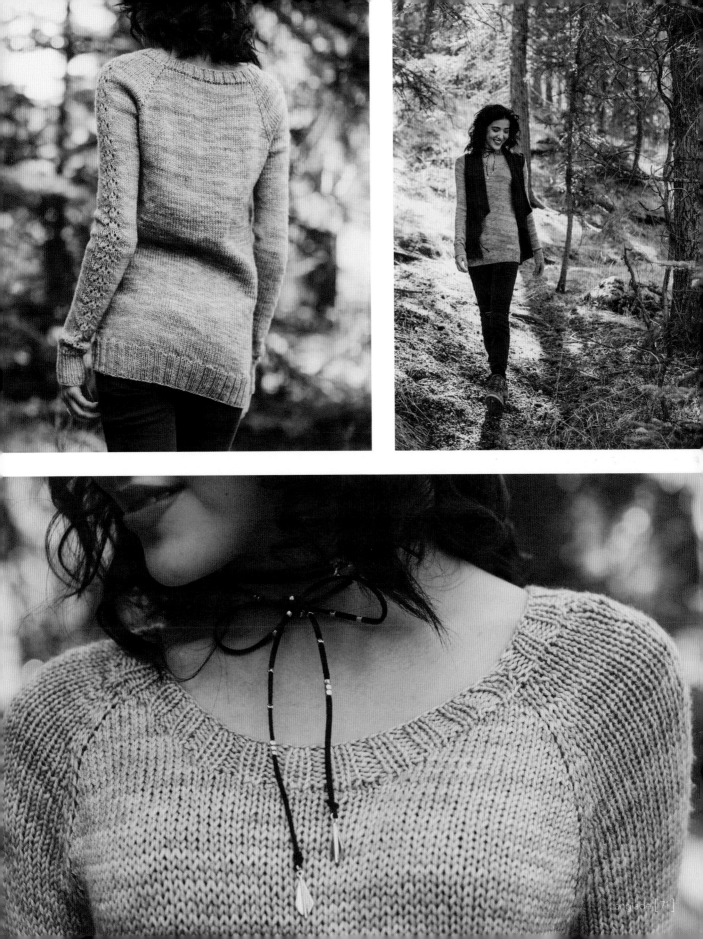

Rep last 4 rows 2 more times, then rep Inc row 3 once more—148 (150, 152, 154, 156, 158, 160, 162) sts, with 17 sts for each front, 33 sts for each sleeve, and 48 (50, 52, 54, 56, 58, 60, 62) sts for back.

Work 1 WS row even.

Joining rnd: (RS) [K1, M1L, knit to 1 st before m, M1R, k1, sm, k1, M1L, knit to 1 st before next raglan m, M1R, k1, sm], 2 times, k1, M1L, knit to last st, M1R, k1, CO 12 (14, 16, 18, 20, 22, 24, 26) sts using Backward Loop method (see Glossary), join for working in rnds, knit to next m—170 (174, 178, 182, 186, 190, 194, 198) sts, with 35 sts for each sleeve, 50 (52, 54, 56, 58, 60, 62, 64) sts each for front and back. Rnds beg at left front raglan.

Knit 1 rnd even, working next row of Lace Panel between lace m.

Inc rnd 1: (body only) [Work to next raglan m, sm, k1, M1L, knit to 1 st before next m, M1R, k1] twice—4 sts inc'd.

Work 1 rnd even.

Inc rnd 2: (body and sleeves) [K1, M1L, work to 1 st before next raglan m, M1R, k1, sm, k1, M1L, knit to 1 st before next raglan m, M1R, k1] twice—8 sts inc'd.

Work 1 rnd even.

Rep last 4 rnds 4 (5, 6, 7, 8, 9, 10, 11) times more—230 (246, 262, 278, 294, 310, 326, 342) sts: 45 (47, 49, 51, 53, 55, 57, 59) sts for each sleeve, and 70 (76, 82, 88, 94, 100, 106, 112) sts each for front and back.

DIVIDE BODY AND SLEEVES

Next rnd: Removing raglan m as you come to them, place 45 (47, 49, 51, 53, 55, 57, 59) sleeve sts on waste yarn, CO 0 (1, 2, 3, 4, 5, 6, 7) st(s) using Backward Loop method, pm for side, CO 0 (1, 2, 3, 4, 5, 6, 7) st(s), knit to raglan m] twice—140 (156, 172, 188, 204, 220, 236, 252) sts.

BODY

Knit 1 rnd even.

Next rnd: P1, knit to 1 st before m, p1, sm, knit to end of rnd.

Rep last rnd until piece measures 15¼ (15½, 16, 16¼, 16½, 17, 17¼, 17½)" (38.5 [39.5, 40.5, 41.5, 42, 43, 44, 44.5] cm) from underarm, or 2½" (6.5 cm) less than desired length.

Change to longer smaller cir needle.

Next rnd: *P2, k2; rep from * to end of rnd.

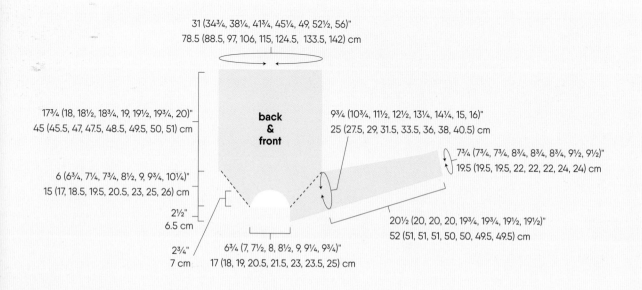

31 (34¾, 38¼, 41¾, 45¼, 49, 52½, 56)"
78.5 (88.5, 97, 106, 115, 124.5, 133.5, 142) cm

17¾ (18, 18½, 18¾, 19, 19½, 19¾, 20)"
45 (45.5, 47, 47.5, 48.5, 49.5, 50, 51) cm

back & front

9¾ (10¾, 11½, 12½, 13¼, 14¼, 15, 16)"
25 (27.5, 29, 31.5, 33.5, 36, 38, 40.5) cm

7¾ (7¾, 7¾, 8¾, 8¾, 8¾, 9½, 9½)"
19.5 (19.5, 19.5, 22, 22, 22, 24, 24) cm

6 (6¾, 7¼, 7¾, 8½, 9, 9¾, 10¼)"
15 (17, 18.5, 19.5, 20.5, 23, 25, 26) cm

2½"
6.5 cm

2¾"
7 cm

6¾ (7, 7½, 8, 8½, 9, 9¼, 9¾)"
17 (18, 19, 20.5, 21.5, 23, 23.5, 25) cm

20½ (20, 20, 20, 19¾, 19¾, 19½, 19½)"
52 (51, 51, 51, 50, 50, 49.5, 49.5) cm

Rep last rnd until ribbing measures 2½" (6.5 cm). BO all sts loosely in ribbing.

SLEEVES (MAKE 2)

Return 45 (47, 49, 51, 53, 55, 57, 59) held sleeve sts to larger dpn, or longer cir needle for working in Magic Loop method (see Glossary). Beg at center of underarm CO, pick up and knit 0 (1, 2, 3, 4, 5, 6, 7) st(s) in CO edge, work sleeve sts in established patt, then pick up and knit 0 (1, 2, 3, 4, 5, 6, 7) st(s) in rem CO edge—45 (49, 53, 57, 61, 65, 69, 73) sts. Pm and join for working in rnds.

Work 23 (15, 11, 11, 10, 8, 8, 7) rnds in established patt.

Dec rnd: K1, k2tog, work to last 3 sts, ssk—2 sts dec'd.

Rep Dec rnd every 24 (16, 12, 12, 11, 9, 9, 8) rnds 1 (5, 7, 7, 4, 5, 5, 6) more time(s), then every 23 (0, 0, 0, 10, 8, 8, 7) rnds 2 (0, 0, 0, 5, 6, 6, 7) times—37 (37, 37, 41, 41, 41, 45, 45) sts rem.

Cont even until sleeve measures 17½ (17, 17, 17, 16¾, 16¾, 16½, 16½)" (44.5 [43, 43, 43, 42.5, 42.5, 42, 42] cm) or 3" (7.5 cm) less than desired length, and dec 1 st at beg of last rnd—36 (36, 36, 40, 40, 40, 44, 44) sts rem.

Change to smaller dpn or longer cir needle for working in Magic Loop method.

Next rnd: *K2, p2; rep from * to end of rnd.

Rep last rnd until ribbing measures 3" (7.5 cm). BO all sts loosely in ribbing.

NECKBAND

With smaller shorter cir needle and RS facing, pick up and knit 30 (32, 34, 36, 38, 40, 42, 44) sts along back neck, 26 sts along top of sleeve, 42 (44, 46, 48, 50, 52, 54, 56) sts along front neck, then 26 sts along top of sleeve—124 (128, 132, 136, 140, 144, 148, 152) sts. Pm and join for working in rnds.

Next rnd: *K2, p2; rep from * to end of rnd.

Rep last rnd until ribbing measures 1" (2.5 cm). BO all sts loosely in ribbing.

Finishing

Weave in ends. Block to measurements.

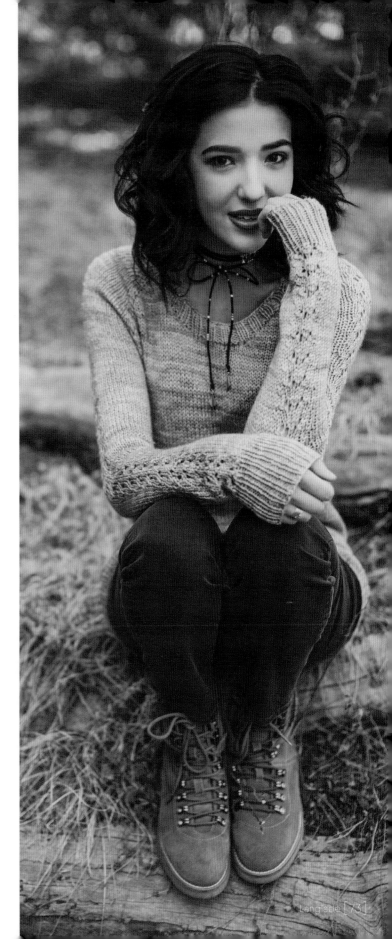

Heyworth

Stitches that mimic the delicious textures of nature cover these soft little mitts. Worked in the round in a fine merino-silk blend that feels delightful on your hands, they are knit from the bottom up with a traditional thumb gusset.

FINISHED SIZES

6 (6½, 6¾)" (15 [16.5, 17] cm) hand circumference and 7¼ (7¾, 7¾)" (18.5 [19.5, 19.5] cm] long.

Sample shown in size 6½" (16.5 cm).

YARN

Sport weight [#2 Fine].

Shown here: Augustbird Egret (70% ethical superfine Australian merino wool, 30% Tussah silk; 312 yd [286 m]/3½ oz [100 g]): Beyond the Teapot, 1 skein.

NEEDLES

Size U.S. 3 (3.25 mm): 24" (60 cm) or longer circular (cir) for working in Magic Loop method, or set of 4 double-pointed (dpn).

Size U.S. 5 (3.75 mm): 24" (60 cm) or longer cir for working in Magic Loop method, or set of 4 dpn.

Adjust needle sizes if necessary to obtain the correct gauge.

NOTIONS

Stitch markers (m); waste yarn; tapestry needle.

GAUGE

25 sts and 35 rnds = 4" (10 cm) in Textured st with larger needles.

NOTES

— The instructions are written for working with the Magic Loop method, but can easily be converted for working with double-pointed needles by dividing the stitches as evenly as possible over three needles; instructions for using double-pointed needles are not included.

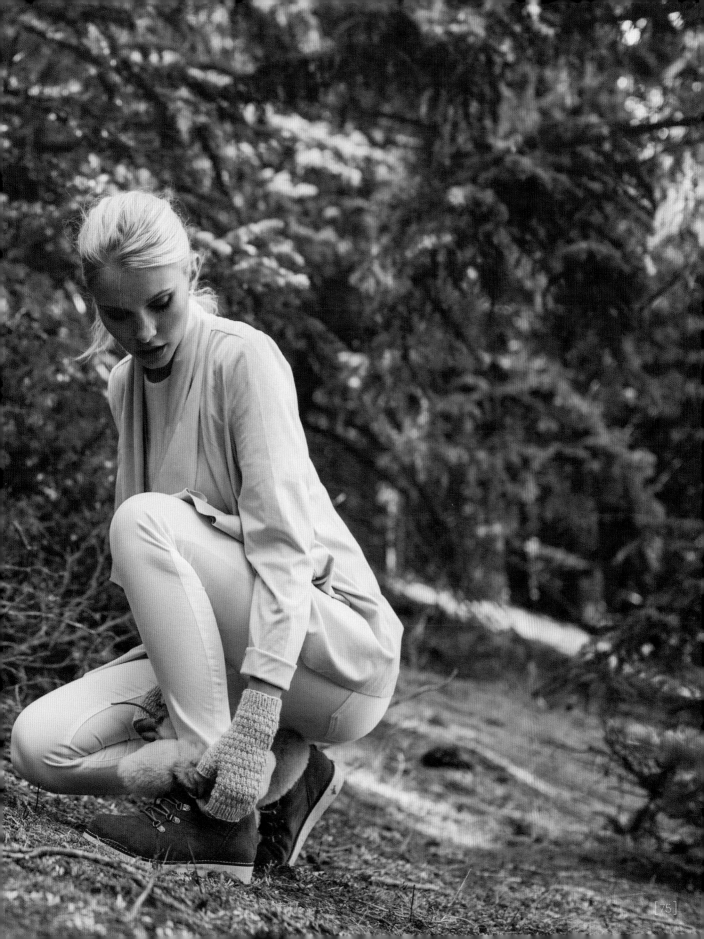

STITCH GUIDE

Texture Pattern

(multiple of 2 sts)

Rnds 1–3: [P1, k1] to end of rnd.

Rnd 4: Knit.

Rnds 5–7: [K1, p1] to end of rnd.

Rnd 8: Knit.

Rep Rnds 1–8 for patt.

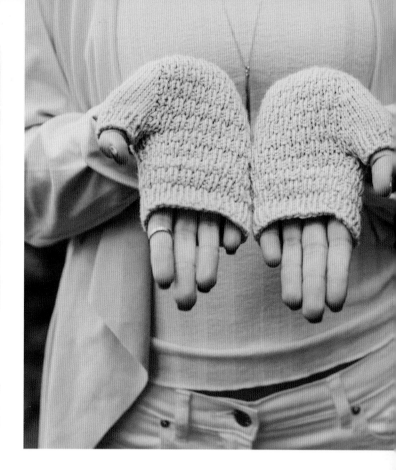

Mitts

With smaller needle, CO 38 (40, 42) sts. Adjust sts along cir needle to work using Magic Loop method (see Glossary). Place marker (pm) and join for working in rnds, being careful not to twist sts.

Rnd 1: *K1, p1; rep from * to end of rnd.

Rep last rnds 9 more times.

Change to larger needle.

Work in Texture Patt (see Stitch Guide) for 8 rnds.

THUMB GUSSET

Set-up rnd: Work in established patt to end of rnd, pm for gusset, M1L—39 (41, 43) sts.

Rnds 1 and 2: Work in established patt to gusset m, sm, knit to end.

Rnd 3: (inc) Work in established patt to m, sm, M1L, knit to end, M1R—2 sts inc'd.

Rep last 3 rnds 7 (8, 8) more times, working sts between gusset m in St st (knit every rnd)—55 (59, 61) sts, with 17 (19, 19) sts for gusset.

Next rnd: Work in established patt to m, remove m and place 17 (19, 19) gusset sts on waste yarn—38 (40, 42) sts rem.

Cont even in established patt for 15 (16, 16) rnds, or until piece measures desired length, ending with Rnd 4 or 8 of patt.

Change to smaller needle. Work 6 rnds in k1, p1 ribbing so knit sts fall above purl sts (see photo).

BO all sts loosely in rib.

THUMB

Return held 17 (19, 19) thumb sts to smaller needle, pick up and knit 1 st in gap at top of opening—18 (20, 20) sts. Pm and join for working in rnds.

Work 4 rnds in k1, p1 ribbing.

BO all sts loosely in rib.

Finishing

Weave in ends. Block lightly to measurements.

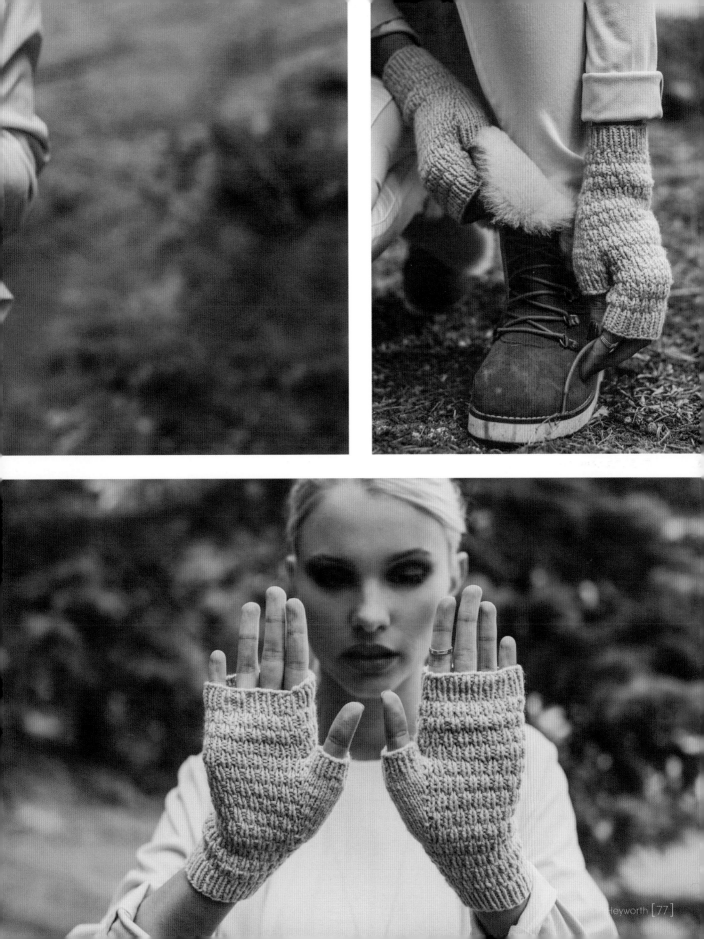

Harrington

Soothing rows of satisfying texture quietly emerge as this chunky scarf falls quickly from the needles. Wrap the resulting oversized, inviting fabric around your neck and step out in comfort and contentment.

FINISHED SIZE

81" (205.5 cm) long and 7" (18 cm) wide.

YARN

Bulky weight [#6 Super Bulky].

Shown here: Julie Asselin Zetta (75% wool, 25% alpaca; 135 yds [123 m]/ 4 oz [115 g]): Birch, 3 skeins.

NEEDLES

Size U.S. 11 (8 mm): straight or circular as preferred.

Adjust needle size if necessary to obtain the correct gauge.

NOTIONS

Tapestry needle.

GAUGE

16 sts and 15 rows = 4" (10 cm) in patt.

STITCH GUIDE

LT (left twist): Knit 2nd st on LH needle tbl, knit first st, then slip both sts from LH needle.

RT (right twist): Knit 2 together, knit first st again, then slip both sts from LH needle.

Scarf

CO 28 sts.

Row 1: (WS) Sl 1 wyf, p1-tbl, k1, *[p1-tbl] 4 times, k2, p1-tbl, k2; rep from * once more, [p1-tbl] 4 times, k1, [p1-tbl] twice.

Row 2: (RS) Sl 1 wyf, k1-tbl, p1, *[k1-tbl] 4 times, p2, k1-tbl, p2; rep from * once more, [k1-tbl] 4 times, p1, [k1-tbl] twice.

Rep last 2 rows 5 times more, then work Row 1 once more.

Next row: (RS) Sl 1 wyf, k1-tbl, p1, [RT, LT, p2, k1-tbl, p2] twice, RT, LT, p1, [k1-tbl] twice.

Next row: (WS) Sl 1 wyf, p1-tbl, k1, [p4, k2, p1-tbl, k2] twice, p4, k1, [p1-tbl] twice.

Repeat last 2 rows until piece measures 77½" (197 cm) from beg, ending with a RS row.

Rep Rows 1 and 2 six times, then rep Row 1 once more.

BO all sts in patt.

Finishing

Weave in ends. Block to measurements.

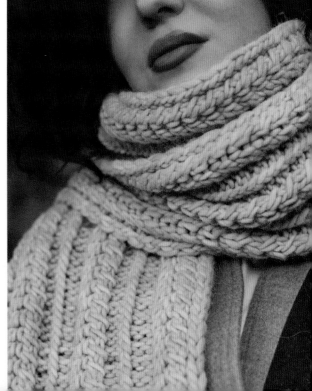

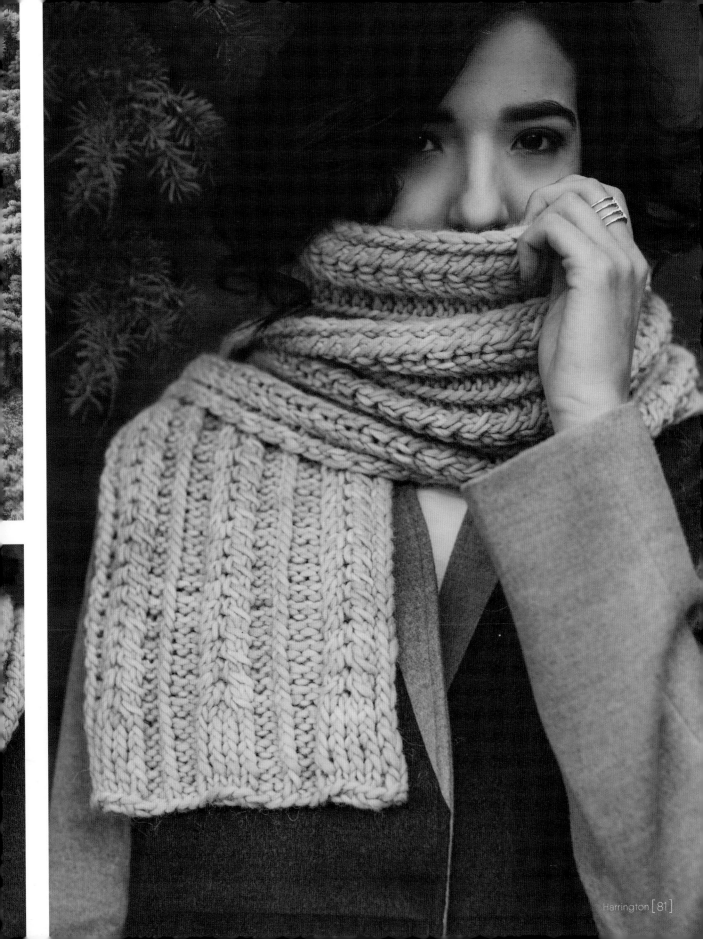

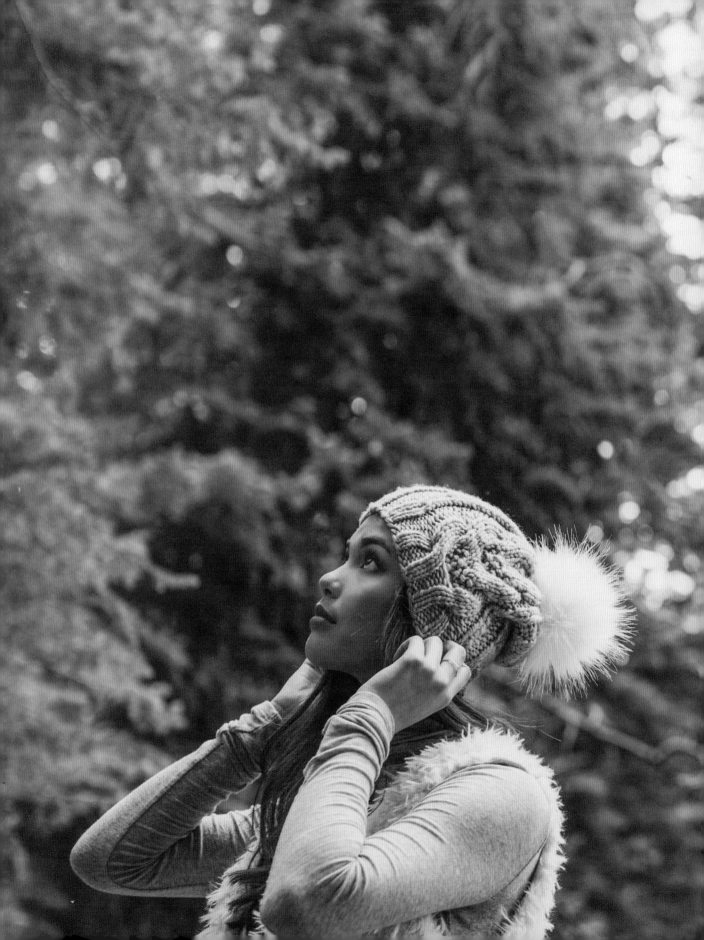

High Cliff

The gentle ripple of the stream relaxes and refreshes you, and the scent of the pine calms and soothes the senses. Worked in the round from the bottom up, this hat is an instant gratification project that knits up quick as a wink.

FINISHED SIZE

16" (40.5 cm) brim circumference and 11" (28 cm) tall.

YARN

Bulky weight [#6 Super Bulky].

Shown here: Madelinetosh Home (100% merino wool; 110 yd [100 m]): Astrid Grey, 1 skein.

NEEDLES

Size U.S. 10 (6 mm): 16" (40 cm) circular (cir).

Size U.S. 11 (8 mm): 16" (40 cm) cir and set of 4 or 5 double-pointed (dpn).

Adjust needle sizes if necessary to obtain the correct gauge.

NOTIONS

Stitch markers (m); cable needle (cn); tapestry needle; faux fur pom-pom (ours was purchased at www.etsy.com/shop/Achillesoriginalart); needle and thread for attaching pom-pom.

GAUGE

11½ sts and 17 rnds = 4" (10 cm) in St st with larger needles.

22-st Cable Panel = approximately 5¼" (13.5 cm) wide.

STITCH GUIDE

4/3 RC (4 over 3 right cross): Sl 3 sts to cn and hold to back of work, k4, k3 from cn.

4/3 LC (4 over 3 left cross): Sl 4 sts to cn and hold to front of work, k3, k4 from cn.

Cable Panel
(panel of 22 sts)

Rnd 1: [K1-tbl] twice, p2, 4/3 RC, 4/3 LC, p2, [k1-tbl] twice.

Rnds 2, 4, and 6: [K1-tbl] twice, p2, k4, [p1, k1] 3 times, k4, p2, [k1-tbl] twice.

Rnds 3 and 5: [K1-tbl] twice, p2, k5, [p1, k1] 3 times, k3, p2, [k1-tbl] twice.

Rnds 7–10: [K1-tbl] twice, p2, k14, p2, [k1-tbl] twice.

Rep Rnds 1–10 for Cable Panel.

Dec rnd 1: [K1-tbl] twice, p2tog, [k2, k2tog] 3 times, k2, p2tog, [k1-tbl] twice, p2tog, [k2, k2tog] to last 4 sts, k2, p2tog—48 sts rem.

Next 2 rnds: [K1-tbl] twice, p1, k11, p1, [k1-tbl] twice, p1, knit to last 3 sts, k2, p1.

Dec rnd 2: *K1, k2tog; rep from * to end—32 sts rem.

Knit 2 rnds even.

Dec rnd 3: [K2tog] around—16 sts rem.

Knit 1 rnd even.

Dec rnd 4: [K2tog] around—8 sts rem.

Cut yarn, leaving an 8" (20.5 cm) tail, thread tail through rem sts and pull tightly to close hole, and fasten off on WS.

Finishing

Weave in ends. Block lightly to measurements. Attach pom-pom to top of hat using needle and thread.

Cap

With smaller needle, CO 64 sts. Place marker (pm) and join for working in rnds, being careful not to twist sts.

Next rnd: *K2, p2; rep from * to end of rnd.

Rep last rnd until ribbing measures 2" (5 cm) from beg.

Change to larger cir needle.

Next rnd: Work Row 1 of Cable Panel over first 22 sts (see Stitch Guide or chart), pm, p2, knit to last 2 sts, p2.

Next rnd: Work Row 2 of Cable Panel, sm, p2, knit to last 2 sts, p2.

Work Rows 3–12 of Cable Panel, rep Rows 1–12 once, then rep Rows 1–6 once more. Piece should measure approximately 9" (23 cm) from beg.

SHAPE CROWN

Change to dpn when there are too few sts to work comfortably on cir needle.

		knit
•		purl
ℓ		k1-tbl
⧄		3/4 RC
⧅		4/3 LC

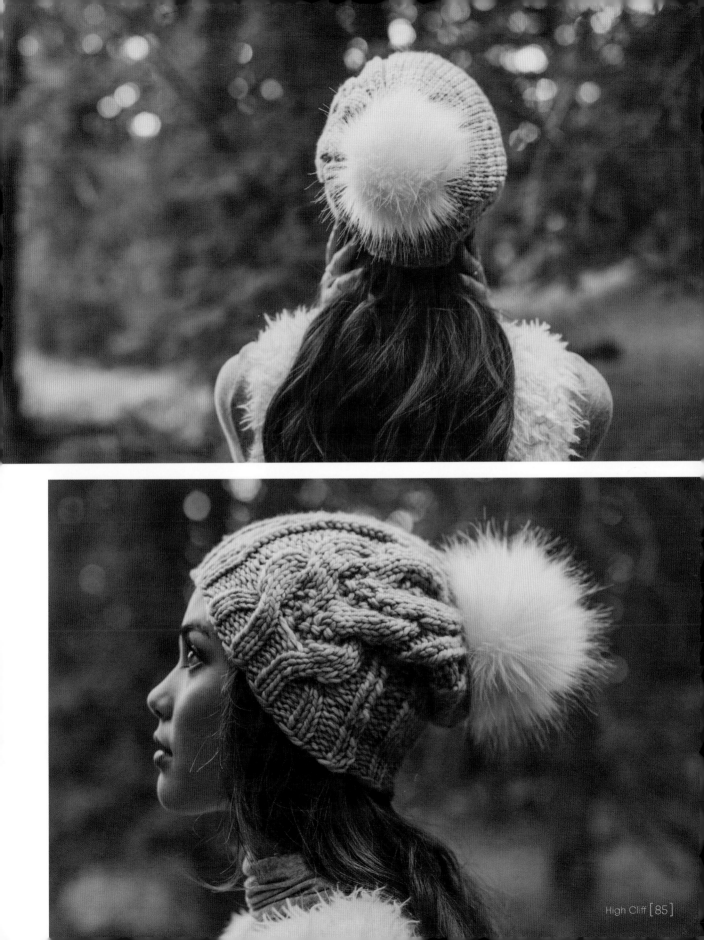

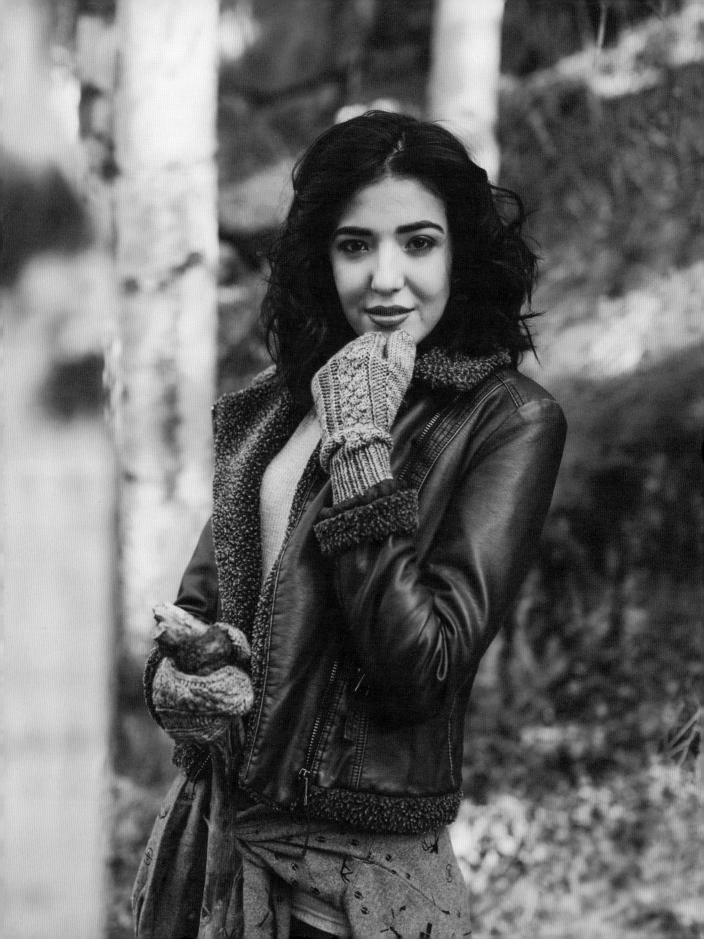

Presque Isle

Braided cables weave their way down the hands, dancing like a waterfall hidden at the end of a remote path. The bit of cashmere in the yarn adds extra warmth and gives these mitts a buttery feel. These mittens are worked in the round, from the bottom up, and the thumb stitches are held, then worked in the round after the hand is complete..

FINISHED SIZE

6" (15 cm) hand circumference and 11" (28 cm) long.

YARN

Worsted weight [#4 Medium].

Shown here: Western Sky Knits Magnolia Worsted (80% merino wool, 10% polyamide, 10% cashmere; 200 yd [183 m]/4 oz [115 g]): Barnwood, 1 skein.

NEEDLES

Size U.S. 6 (4 mm): set of 4 double-pointed (dpn).

Size U.S. 7 (4.5 mm): set of 4 dpn.

Adjust needle sizes if necessary to obtain the correct gauge.

NOTIONS

Stitch markers (m); cable needle (cn); waste yarn; tapestry needle.

GAUGE

19 sts and 27 rnds = 4" (10 cm) in St st with larger needles.

18-st Cable Panel = approximately 2¼" (5.5 cm) wide.

STITCH GUIDE

2/2 RC (2 over 2 right cross): Sl 2 sts to cn and hold in back of work, k2, k2 from cn.

2/2 LC (2 over 2 left cross): Sl 2 sts to cn and hold in front of work, k2, k2 from cn.

Cable Panel
(panel of 18 sts)

Rnds 1 and 3: P3, k1-tbl, p1, k8, p1, k1-tbl, p3.

Rnd 2: P3, k1-tbl, p1, [2/2 RC] twice, p1, k1-tbl, p3.

Rnd 4: P3, k1-tbl, p1, k2, 2/2 LC, k2, p1, k1-tbl, p3.

Rep Rnds 1–4 for Cable Panel.

Mittens

RIGHT MITTEN

With smaller dpn, CO 30 sts using Long Tail method (see Glossary). Place marker (pm) and join for working in rnds, being careful not to twist sts.

Next rnd: *K1, p1; rep from * to end of rnd.

Rep last rnd until ribbing measures 2¾" (7 cm) from beg.

Change to larger dpn.

Inc rnd: [K5, m1] 3 times, pm for side, [k5, m1] 3 times—36 sts.

Next rnd: K18, sm, work Rnd 1 of Cable Panel (see Stitch Guide or chart) over next 18 sts.

Cont in established patt for 7 more rnds.

Thumb Gusset

Set-up rnd: K18, sm, work Rnd 1 of Cable Panel, pm for gusset, M1R—37 sts.

Inc rnd: Work in established patt to gusset m, sm, M1R, knit to m, M1L—2 sts inc'd.

Next 2 rnds: Work in established patt to gusset m, sm, knit to end of rnd.

Rep last 3 rnds 6 more times—51 sts, with 15 sts for thumb gusset.

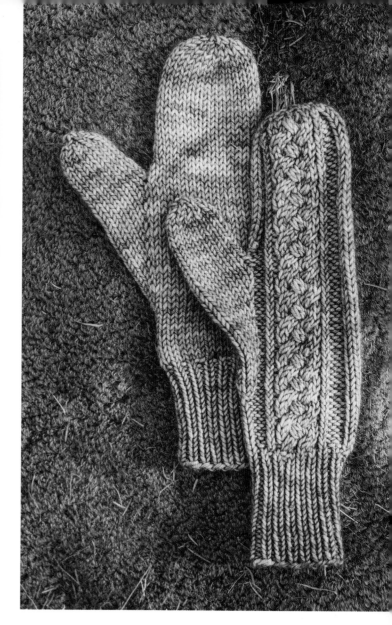

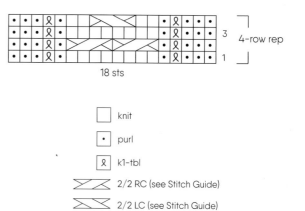

3

4-row rep

1

18 sts

☐ knit

• purl

ℒ k1-tbl

2/2 RC (see Stitch Guide)

2/2 LC (see Stitch Guide)

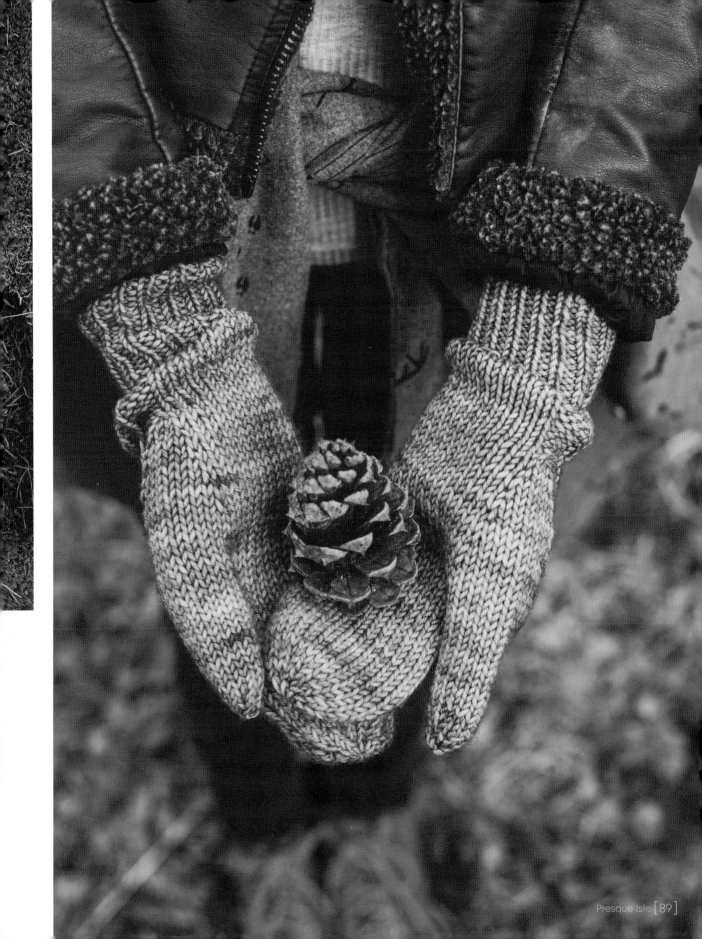

Next rnd: Work to gusset m, remove m and place 15 thumb sts on waste yarn—36 sts rem.

Cont even in established patt until piece measures approximately ½" (1.3 cm) less than desired length.

Shape mitten tip

Dec rnd: [K2tog] 9 times, p2tog, [k2tog] 7 times, p2tog—18 sts rem.

Next rnd: K9, p1, k7, p1.

Dec rnd: [K2tog] 9 times—9 sts rem.

Cut yarn, leaving an 8" (20.5 cm) tail, thread tail through rem sts and pull tightly to close hole, and fasten off on WS.

Thumb

Return held 15 thumb sts to smaller dpn, pick up and knit 2 sts in gap at top of opening—17 sts. Distribute sts evenly over 3 dpn. Pm and join for working in rnds.

Work even in St st (knit every rnd) until thumb measures approximately ½" (1.3 cm) less than desired length.

Shape thumb tip

Dec rnd: [K2tog] 8 times, k1—9 sts rem.

Knit 1 rnd even.

Dec rnd: [K2tog] 4 times, k1—5 sts rem.

Cut yarn, leaving an 8" (20.5 cm) tail, thread tail through rem sts and pull tightly to close hole, and fasten off on WS.

LEFT MITTEN

With smaller dpn, CO 30 sts using Long Tail method (see Glossary). Place marker (pm) and join for working in rnds, being careful not to twist sts.

Next rnd: *K1, p1; rep from * to end of rnd.

Rep last rnd until ribbing measures 2¾" (7 cm) from beg.

Change to larger dpn.

Inc rnd: [K5, m1] 3 times, pm for side, [k5, m1] 3 times—36 sts.

Next rnd: Work Rnd 1 of Cable Panel (see Stitch Guide or chart) over next 18 sts, sm, knit to end of rnd.

Cont in established patt for 7 more rnds.

Thumb Gusset

Set-up rnd: Work Rnd 1 of Cable Panel, sm, k18, pm for gusset, M1R—37 sts.

Inc rnd: Work in established patt to gusset m, sm, M1R, knit to m, M1L—2 sts inc'd.

Next 2 rnds: Work in established patt to gusset m, sm, knit to end of rnd.

Rep last 3 rnds 6 more times—51 sts, with 15 sts for thumb gusset.

Next rnd: Work to gusset m, remove m and place 15 thumb sts on waste yarn—36 sts rem.

Cont even in established patt until piece measures approximately ½" (1.3 cm) less than desired length.

Shape mitten tip

Dec rnd: P2tog, [k2tog] 7 times, p2tog, [k2tog] 9 times—18 sts rem.

Next rnd: P1, k7, p1, k9.

Dec rnd: [K2tog] 9 times—9 sts rem.

Cut yarn, leaving an 8" (20.5 cm) tail, thread tail through rem sts and pull tightly to close hole, and fasten off on WS.

Thumb

Work thumb same as for right mitten.

Finishing

Weave in ends. Block lightly to measurements.

Rockland

Boulders loom out of the mountainside, covered in moss and providing refuge for local wildlife. Each crag and prominence of the boulder is represented in the textured surface of the Rockland hat. Casual yet polished, and knit in a supremely warm alpaca blend, this hat is perfect protection against nature's cold winds. It is worked in the round from the bottom up.

FINISHED SIZE

18" (45.5 cm) circumference above brim and 11" (28 cm) tall.

YARN

Aran weight [#4 Medium].

Shown here: Blue Sky Fibers Extra (55% baby alpaca, 45% fine merino wool; 218 yd [199 m]/5¼ oz [150 g]): #3520 Shale, 1 skein.

NEEDLES

Size U.S. 7 (4.5 mm): 16" (40 cm) circular (cir).

Size U.S. 9 (5.5 mm): 16" (40 cm) cir, and set of 4 or 5 double-pointed (dpn).

Adjust needle sizes if necessary to obtain the correct gauge.

NOTIONS

Stitch markers (m); cable needle (cn); spare size U.S. 7 (4.5 mm) cir needle (optional); tapestry needle.

GAUGE

19½ sts and 28 rnds = 4" (10 cm) in Honeycomb Patt with larger needles.

NOTES

— Be sure to block the hat thoroughly to smooth out the points left by the crown decreases and to bloom the cables.

— Two versions of the brim are given. The folded stockinette/rib brim is shown. Alternatively, the brim can be worked in rib only.

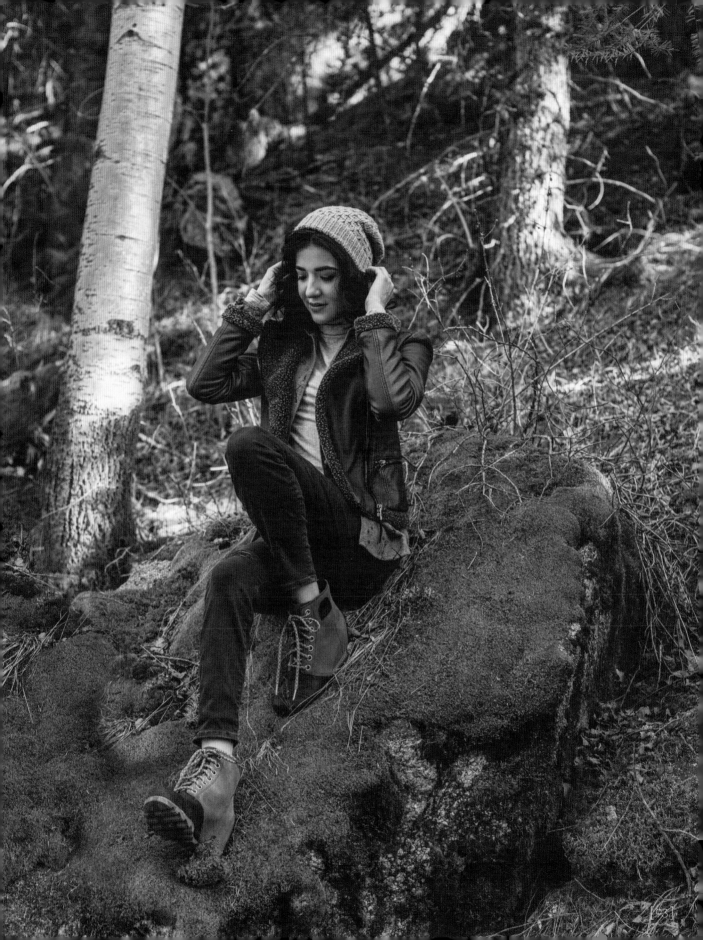

STITCH GUIDE

1/1 LC (1 over 1 left cross): Sl 1 st to cn and hold to front of work, k1, k1 from cn.

1/1 RC (1 over 1 right cross): Sl 1 st to cn and hold to back of work, k1, k1 from cn.

Honeycomb Pattern
(multiple of 4 sts)

Rnd 1: *1/1 RC, 1/1 LC; rep from * to end.

Rnds 2, 3, 4, 6, 7, and 8: Knit.

Rnd 5: *1/1 LC, 1/1 RC; rep from * to end.

Rep Rnds 1–8 for patt.

Hat

FOLDED STOCKINETTE/RIB BRIM (SHOWN)
With smaller needle, CO 80 sts.

Note: *The stitches will later be joined to the inner brim to give a double thickness brim; I HIGHLY suggest a provisional cast-on method (see Glossary for one method). Place marker (pm) and join for working in rnds, being careful not to twist sts.*

Rnd 1: *K1, p1; rep from * to end of rnd.

Rep last rnd until ribbing measures 2¼" (5.5 cm).

Work in St st (knit every rnd) for 2¼" (5.5 cm).

For provisional cast-on only
Remove provisional CO and place resulting sts on a spare cir needle.

Fold work in half with spare needle in front, and both cir needles parallel. Using right needle tip from back needle, [knit together 1 st from front needle and 1 st from back needle] around.

If you did not use a provisional cast-on, you can sew the cast-on edge to inside of the brim when hat is completed.

RIBBED BRIM (ALTERNATIVE)
With smaller needle, CO 80 sts using Long Tail Tubular method (see Glossary). Pm and join for working in rnds, being careful not to twist sts.

Rnd 1: *K1, p1; rep from * to end of rnd.

Rep last rnd until ribbing measures 2¼" (5.5 cm).

BODY (BOTH BRIM VERSIONS)
Change to larger cir needle.

Inc rnd: *K9, k1f&b; rep from * to end of rnd—88 sts.

Work Honeycomb Pattern (see Stitch Guide) until piece measures approx 9" (23 cm) from fold edge or beg edge, ending with Rnd 5 of patt.

CROWN SHAPING
Note: *Change to dpn when too few sts rem to work comfortably on cir needle.*

Rnd 1: *K2tog, k18, ssk, pm; rep from * to end of rnd—80 sts rem.

Rnds 2, 6, 10, and 14: Knit, slipping m as you come to them.

Rnds 3, 5, 7, 9, 11, 13, and 15: *K2tog, knit to 2 sts before m, ssk, sm; rep from * to end of rnd—8 sts dec'd.

Rnds 4, 8, 12, and 16: *[1/1 LC, 1/1 RC] to 2 sts before m, 1/1 LC, sm, [1/1 RC, 1/1 LC] to 2 sts before m, 1/1 RC; rep from * once more.

Rnd 17: [K2tog] around—12 sts rem.

Cut yarn, leaving an 8" (20.5 cm) tail, thread tail through rem sts, pull tightly to close hole, fasten off on WS.

Finishing

Weave in all ends. Block lightly to finished measurements.

Sew CO edge for folded brim if provisional CO was not used.

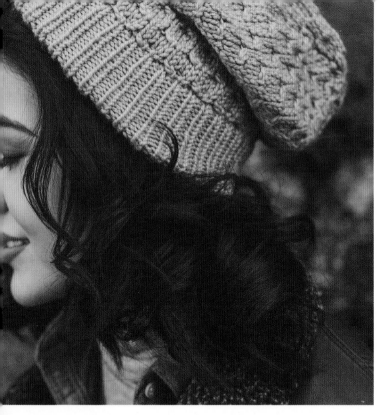

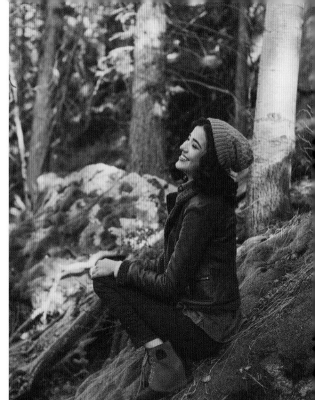

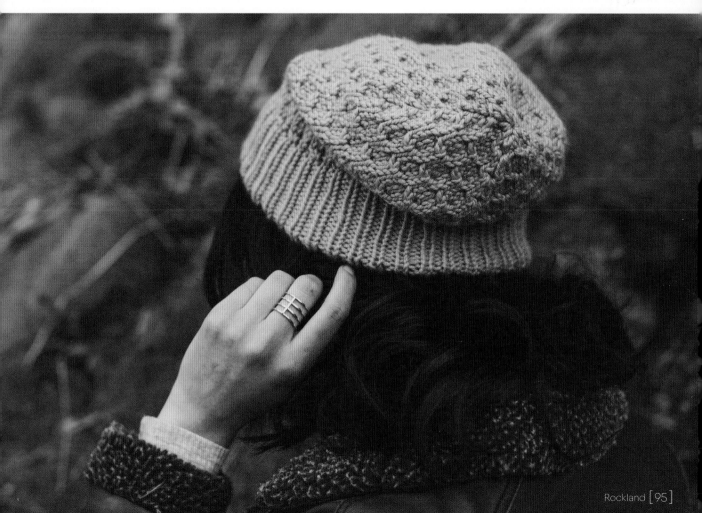

Bretton Woods

Gentle folds of fabric mimic the rush of a woodland stream, smoothing over moss covered rocks and singing a forgotten song. Subtle stripes capture the nuances seen through the bottom of a brook in the shade. Bretton Woods is a quick, simple knit worked in a luscious merino-alpaca yarn from the bottom up, seamlessly in the round.

FINISHED SIZE

27½" (70 cm) circumference and 16½" (42 cm) tall.

YARN

Worsted weight [#4 Medium].

Shown here: Cascade Yarns Eco Cloud (70% undyed merino wool, 30% undyed baby alpaca; 164 yd [150 m]/3½ oz [100 g]): #1802 Ecru (A) and #1801 Cream (B), 2 skeins each.

NEEDLES

Size U.S. 11 (8 mm): 32" (80 cm) circular (cir).

Adjust needle size if necessary to obtain the correct gauge.

NOTIONS

Stitch marker (m); tapestry needle.

GAUGE

19 sts and 23 rnds = 4" (10 cm) in Fisherman's Rib, relaxed.

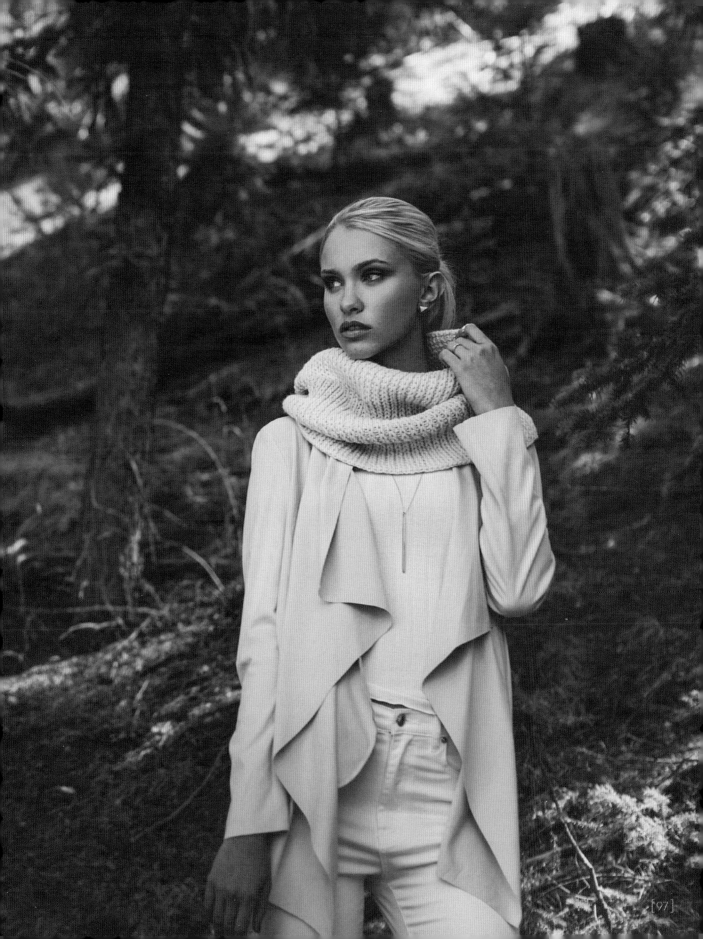

STITCH GUIDE

Fisherman's Rib (multiple of 2 sts)

Rnd 1: *K1, p1; rep from * to end.

Rnd 2: *Sl 1 wyb, p1; rep from * to end.

Rep Rnds 1 and 2 for patt.

Cowl

With A, CO 132 sts using the Long Tail method (see Glossary). Place marker (pm) and join for working in rnds, being careful not to twist sts.

*Work 16 rnds of Fisherman's Rib (see Stitch Guide).

Change to B and work 16 rnds of Fisherman's Rib.

Change to A.

Rep from * 2 more times, and do not change to A at end of last rep.

BO all sts loosely using Sewn method (see Glossary).

Finishing

Weave in all ends. Block lightly.

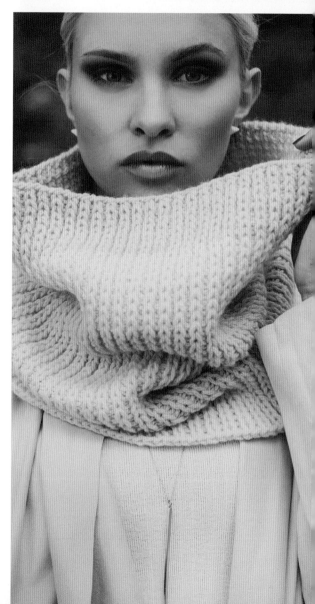

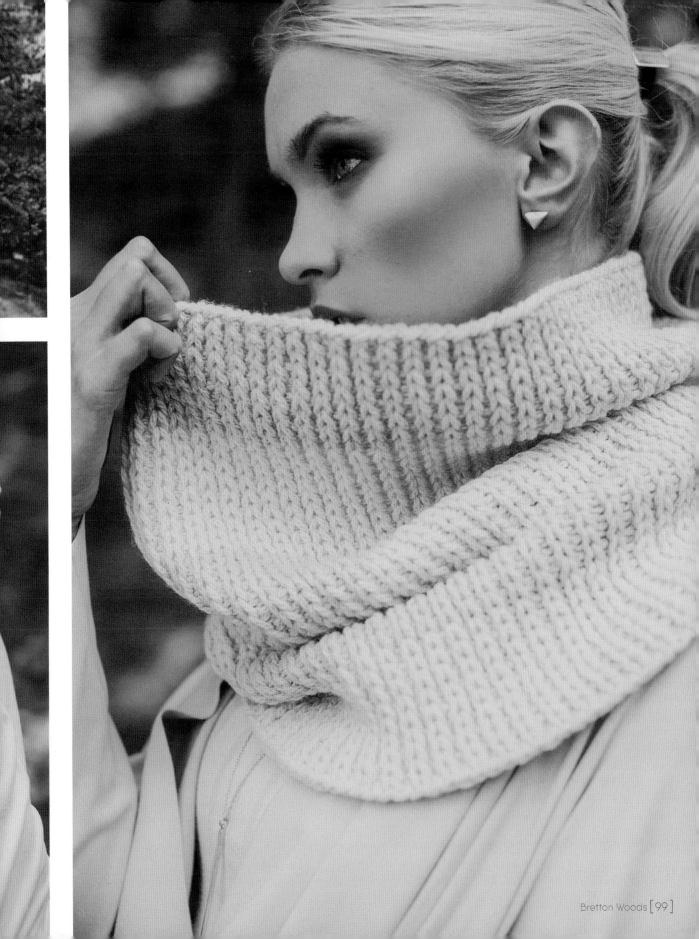

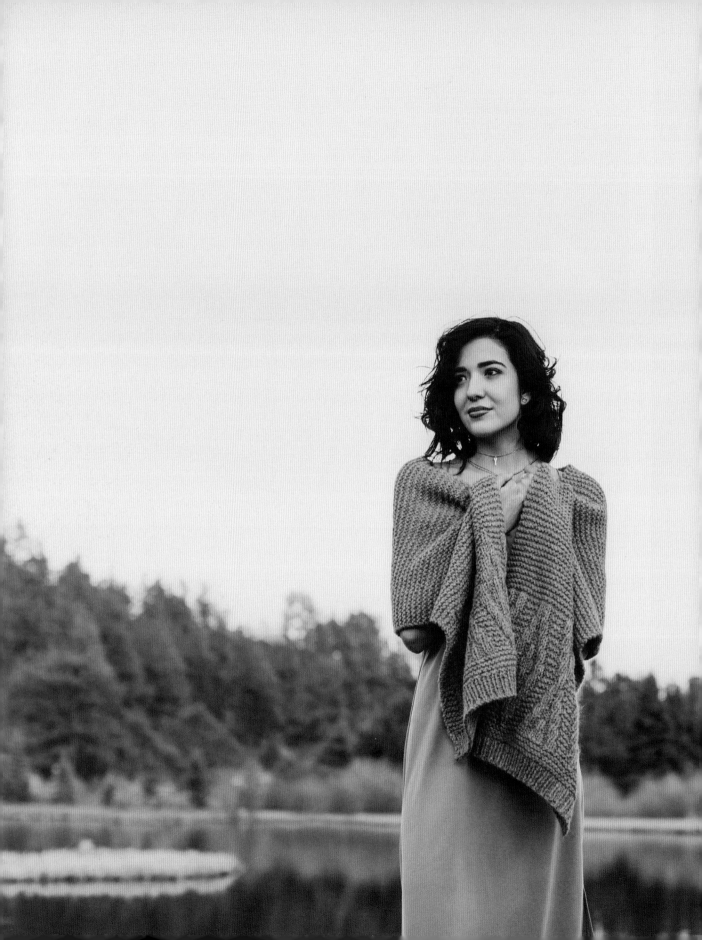

Prescott

Well trodden paths through mountainous trails are represented by the x-and-o motifs adorning each edge. This thick, luxe shawl is perfect for wrapping up in during any season. Knitted flat from the bottom up, the squishy Garter stitch and an oversize canvas guarantee warmth and comfort.

FINISHED SIZE

62" (157.5 cm) long and 16" (40.5 cm) wide.

YARN

Chunky weight [#5 Bulky].

Shown here: Berroco Ultra Alpaca Chunky (50% alpaca, 50% wool; 131 yd [129 m]/3½ oz [100 g]): #7206 Light Grey, 5 skeins.

NEEDLES

Size U.S. 10½ (6.5 mm): straight or circular as preferred.

Size U.S. 11 (8 mm): straight or circular as preferred.

Adjust needle sizes if necessary to obtain correct gauge.

NOTIONS

Stitch markers (m); tapestry needle.

GAUGE

13 sts and 22 rows = 4" (10 cm) in Garter st with larger needles.

Wrap

With smaller needles, CO 52 sts using Long Tail method (see Glossary).

Row 1: (RS) *K1, p1; rep from * to end of row.

Row 2: (WS) *K1, p1; rep from * to end of row.

Rep Rows 1 and 2 until ribbing measures 2" (5 cm), ending with a WS row.

Change to larger needles. Work 8 rows in Garter st (knit every row).

Next row: (RS) K4, place marker (pm), work Row 1 of chart twice across next 44 sts, pm, k4.

Next row: (WS) K4, sm, work Row 2 of chart twice to m, sm, k4.

Cont as established through Row 40 of chart and remove m on last row.

Work in Garter st until piece measures approximately 51" (129.5 cm) from beg, ending with a WS row.

Next row: (RS) K4, pm, work Row 1 of chart twice across next 44 sts, pm, k4.

Next row: (WS) K4, sm, work Row 2 of chart twice to m, sm, k4.

Cont as established through Row 40 of chart and remove m on last row.

Work 8 rows in Garter st.

Change to smaller needles. Rep Rows 1 and 2 until ribbing measures 2" (5cm).

BO all sts loosely in rib.

Finishing

Weave in ends. Block to measurements.

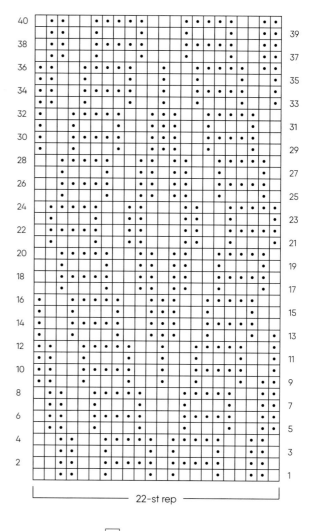

22-st rep

k on RS, p on WS

• p on RS, k on WS

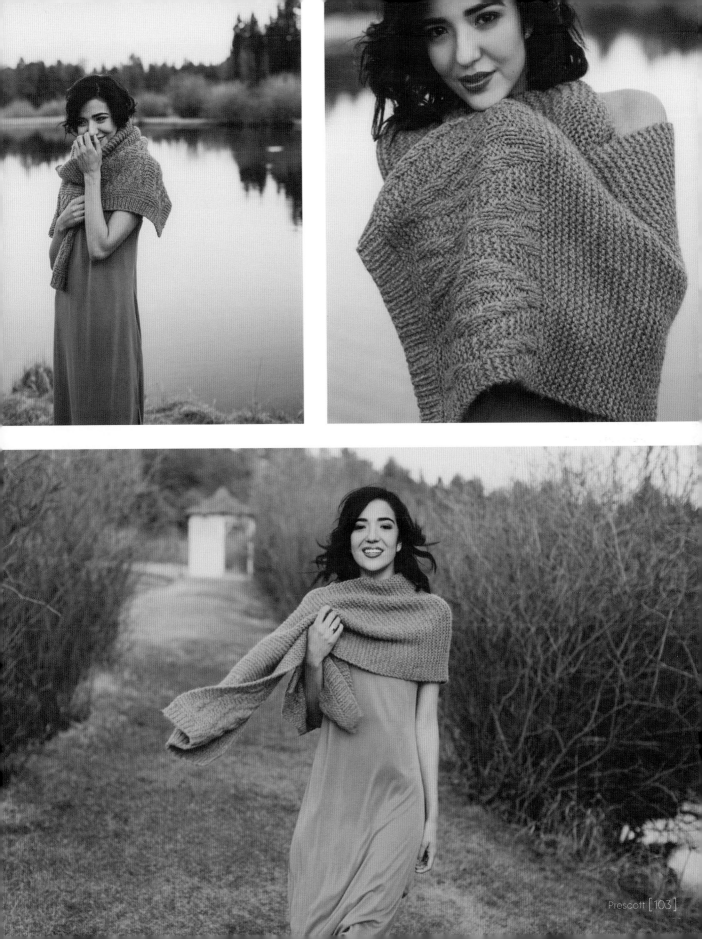

Stowe

Inspired by the small ski town nestled in Vermont's Green Mountains, this hat is perfect for Apres ski. Merino-silk yarn adds coziness to the honeycomb-like stitch pattern as it weaves its way around the main body of this hat. Stowe is worked in the round from the bottom up and topped off with a pom. The stitch pattern is evocative of cablework without the effort.

FINISHED SIZE

16" (40.5 cm) circumference above brim and 9" (23 cm) tall with brim folded.

YARN

DK weight [#3 Light].

Shown here: Julie Asselin Leizu DK (90% merino wool, 10% silk; 260 yd [238 m]/4 oz [115 g]): Confiture, 1 skein.

NEEDLES

Size U.S. 7 (4.5 mm): 16" (40 cm) circular (cir).

Size U.S. 9 (5.5 mm): 16" (40 cm) cir and set of 4 or 5 double-pointed (dpn).

Adjust needle sizes if necessary to obtain the correct gauge.

NOTIONS

Stitch markers (m); tapestry needle; faux fur pom-pom (ours was purchased at www.etsy.com/shop/Achillesoriginalart); needle and thread for attaching pom-pom.

GAUGE

24 sts and 27 rnds = 4" (10 cm) in Circle Brocade patt with larger needle.

NOTES

— If you don't want a folded rib brim, work 2½" (6.5 cm) of rib before changing to the larger needles.

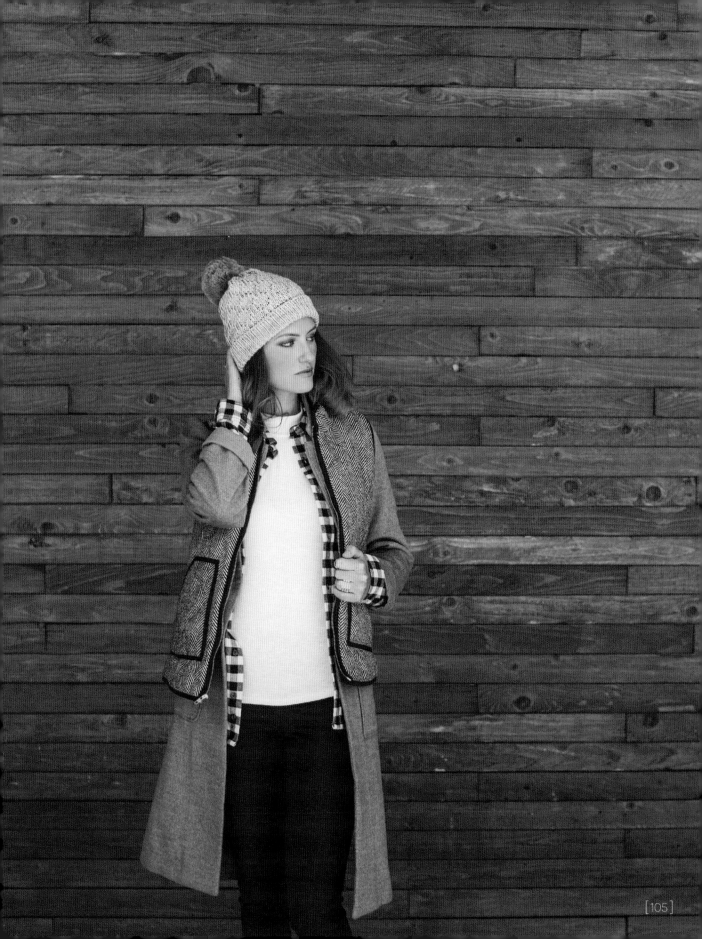

STITCH GUIDE

Circle Brocade Pattern
(multiple of 8 sts)

Rnds 1–4: P3, *k1-tbl, p1, k1-tbl, p5; rep from * to last 5 sts, k1-tbl, p1, k1-tbl, p2.

Rnds 5 and 6: P2, *k1-tbl, p3; rep from * to last 2 sts, k1-tbl, p1.

Rnds 7–10: P1, *k1-tbl, p5, k1-tbl, p1; rep from * to last 7 sts, k1-tbl, p5, k1-tbl.

Rnds 11 and 12: Rep Rnds 5 and 6.

Rep Rnds 1–12 for patt.

Hat

With smaller cir needle, CO 94 sts, using Long Tail Tubular method (see Glossary). Place marker (pm) and join for working in rnds, taking care not to twist sts.

Rnd 1: *K1, p1; rep from * to end of rnd.

Rep last rnd until ribbing measures 4" (10 cm) from beg.

Change to larger needle.

Inc rnd: *K46, k1f&b; rep from * once more—96 sts.

Work in Circle Brocade patt (see Stitch Guide or chart) for approximately 5" (12.5 cm), ending with Rnd 10 of patt.

SHAPE CROWN

Change to dpn when there are too few sts to work comforatbly on cir needle.

Rnd 1: (dec) *K2tog, k1-tbl, p3, k1-tbl, p3, ssk, pm; rep from * 5 more times—84 sts rem.

Rnd 2: *K1, [k1-tbl, p3] 3 times, k1, sm; rep from * to end of rnd.

Rnd 3: (dec) *K2tog, k1-tbl, p1, k1-tbl, p5, k1-tbl, p1, ssk, sm; rep from * 5 more times—72 sts rem.

Rnd 4: *K1, k1-tbl, p1, k1-tbl, p5, k1-tbl, p1, k1, sm; rep from * to end of rnd.

Rnd 5: (dec) *K2tog, p1, k1-tbl, p5, k1-tbl, ssk, sm; rep from * 5 more times—60 sts rem.

Rnd 6: *K1, p1, k1-tbl, p5, k1-tbl, k1, sm; rep from * to end of rnd.

Rnd 7: (dec) *K2tog, p1, k1-tbl, p3, k1-tbl, ssk, sm; rep from * 5 more times—48 sts rem.

Rnd 8: *K1, p1, k1-tbl, p3, k1-tbl, k1, sm; rep from * to end of rnd.

Rnd 9: (dec) *K2tog, [p1, k1-tbl] twice, ssk, sm; rep from 5 more times—36 sts rem.

Rnd 10: *K1, [p1, k1-tbl] twice, p1, sm; rep from * to end of rnd.

Rnd 11: (dec) *K2tog, k1-tbl, p1, ssk, sm; rep from * 5 more times—24 sts rem.

Rnd 12: *K1, k1-tbl, p1, k1, sm; rep from * to end of rnd.

Rnd 13: (dec) *K2tog, ssk, sm; rep from * 5 more times—12 sts rem.

Rnd 14: (dec) [K2tog] around, removing m—6 sts rem.

Cut yarn, leaving an 8" (20.5 cm) tail, thread tail through rem sts, pulling tightly to close hole, and fasten off on WS.

Finishing

Weave in ends. Block lightly to measurements. Attach pom-pom to top of hat using needle and thread.

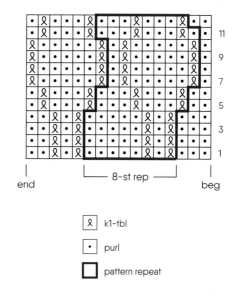

	k1-tbl
•	purl
☐	pattern repeat

end ⌐ 8-st rep ⌐ beg

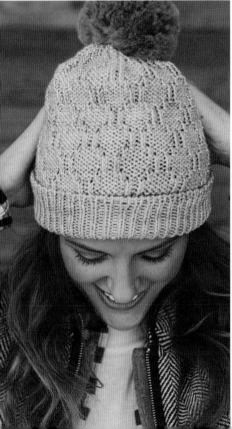

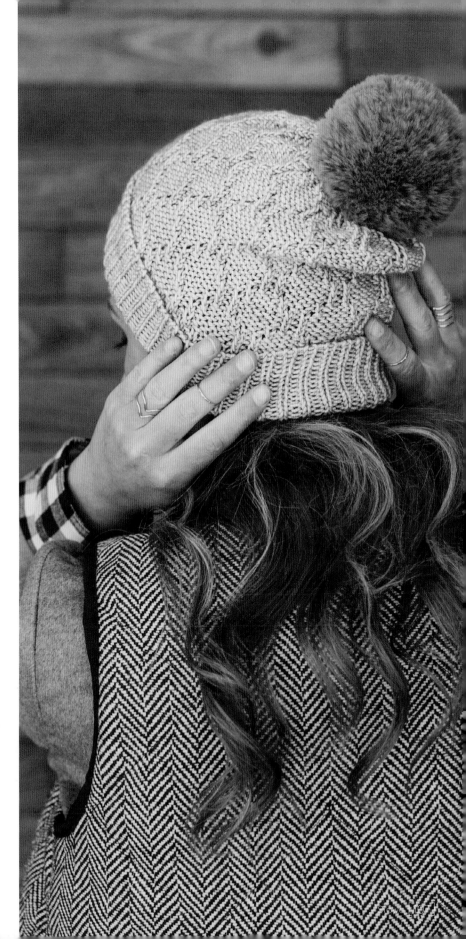

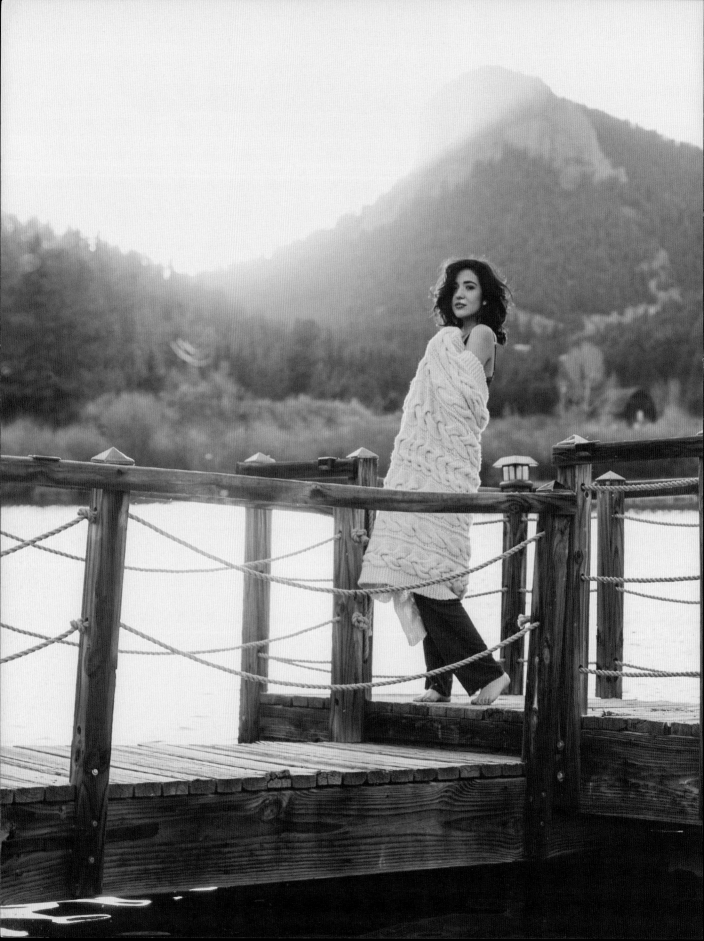

Mackinaw

The stress of the day melts away as you pull the massive, soft cables of this blanket around you, enveloping yourself in luxury and letting tranquility overcome you. This cabled blanket is worked in one piece from the bottom up.

FINISHED SIZE

40" (101.5 cm) wide and 55½" (141 cm) long.

YARN

Chunky weight [#5 Bulky].

Shown here: Malabrigo Chunky (100% merino wool; 104 yd [95 m]/3½ oz [100 g]): #CH063 Natural, 14 skeins.

NEEDLES

Size U.S. 13 (9 mm): 40" (100 cm) circular (cir).

Adjust needle size if necessary to obtain the correct gauge.

NOTIONS

Stitch markers (m); cable needle (cn); tapestry needle.

GAUGE

Approx 15 and 14 rows = 4" (10 cm) in patt.

NOTES

— A long circular needle is used to accommodate the large number of stitches. Work back and forth, do not join.

STITCH GUIDE

Note: See page 112 for charts for Cables A, B, and C.

4/4 RC (4 over 4 right cross): Sl 4 sts to cn and hold in back of work, k4, k4 from cn.

4/4 LC (4 over 4 left cross): Sl 4 sts to cn and hold in front of work, k4, k4 from cn.

5/5 RC (5 over 5 right cross): Sl 5 sts to cn and hold in back of work, k5, k5 from cn.

5/5 LC (5 over 5 left cross): Sl 5 sts to cn and hold in front of work, k5, k5 from cn.

6/6 RC (6 over 6 right cross): Sl 6 sts to cn and hold in back of work, k6, k6 from cn.

6/6 LC (6 over 6 left cross): Sl 6 sts to cn and hold in front of work, k6, k6 from cn.

Cable A
(panel of 54 sts)

Rows 1, 5, 7, and 11: (RS) K18, p2, k1-tbl, p2, k8, p2, k1-tbl, p2, k18.

Row 2 and all other WS rows: P18, k2, p1-tbl, k2, p8, k2, p1-tbl, k2, p18.

Row 3: 6/6 RC, k6, p2, k1-tbl, p2, k8, p2, k1-tbl, p2, 6/6 RC, k6.

Row 9: K6, 6/6 LC, p2, k1-tbl, p2, 4/4 RC, p2, k1-tbl, p2, k6, 6/6 LC.

Row 12: Rep Row 2.

Rep Rows 1–12 for Cable A.

Cable B
(panel of 24 sts)

Rows 1, 3, and 5: (RS) P2, k20, p2.

Row 2 and all other WS rows: K2, p20, k2.

Row 7: P2, 5/5 RC, 5/5 LC, p2.

Row 8: Rep Row 2.

Rep Rows 1–8 for Cable B.

Cable C
(panel of 54 sts)

Rows 1, 5, 7, and 11 (RS): K18, p2, k1-tbl, p2, k8, p2, k1-tbl, p2, k18.

Row 2 and all other WS rows: P18, k2, p1-tbl, k2, p8, k2, p1-tbl, k2, p18.

Row 3: 6/6 RC, k6, p2, k1-tbl, p2, k8, p2, k1-tbl, p2, 6/6 RC, k6.

Row 9: K6, 6/6 LC, p2, k1-tbl, p2, 4/4 LC, p2, k1-tbl, p2, k6, 6/6 LC.

Row 12: Rep Row 2.

Rep Rows 1–12 for Cable C.

Throw

CO 148 sts. Do not join.

Work 8 rows in Garter st (knit every row).

Set-up row: (RS) K8, place marker (pm), working Row 1 of each panel (see Stitch Guide or charts), work Cable A over next 54 sts, pm, Cable B over next 24 sts, pm, Cable C over next 54 sts, pm, k8.

Next row: (WS) K8, sm, working Row 2 of each panel, work Cable C over next 54 sts, sm, Cable B over next 24 sts, sm, Cable A over next 54 sts, sm, k8.

Cont in established patt until piece measures approximately 53½" (136 cm) from beg, ending with a WS row.

Work 8 rows in Garter st over all sts.

BO all sts kwise.

Finishing

Weave in ends. Block to measurements.

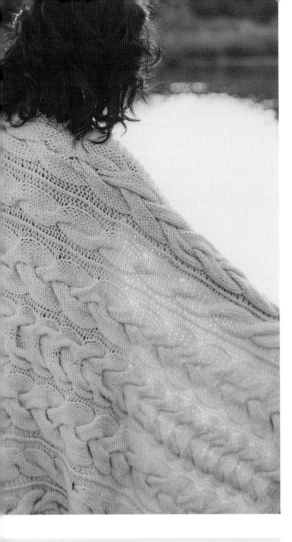

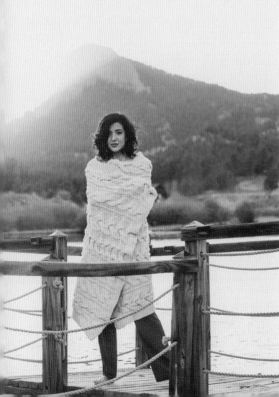

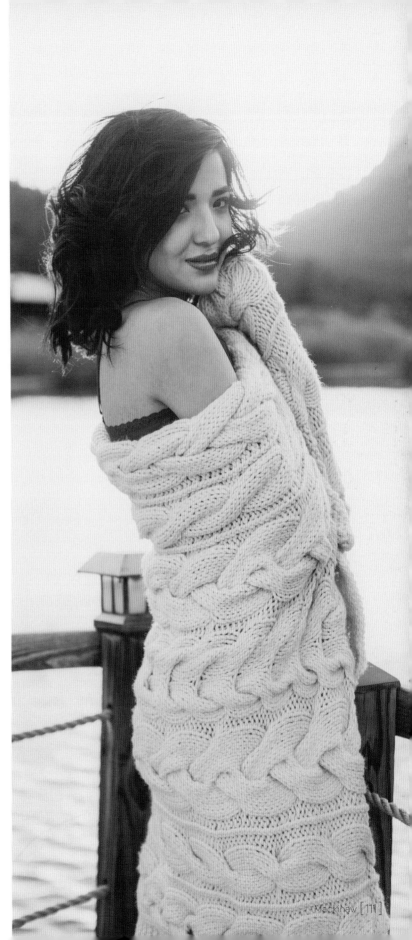

Cable A

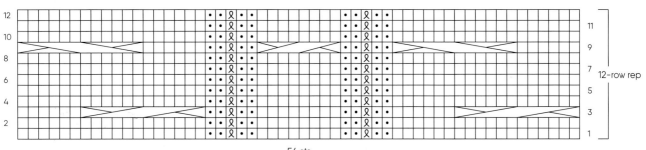

54 sts

12-row rep

Cable B

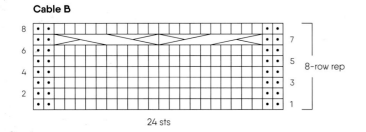

24 sts

8-row rep

Cable C

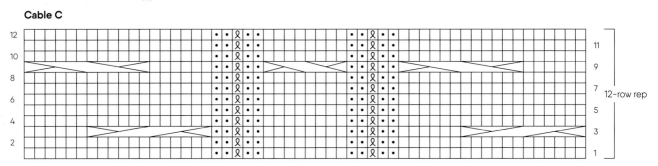

54 sts

12-row rep

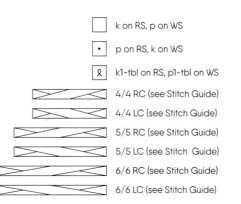

☐	k on RS, p on WS
•	p on RS, k on WS
ℓ	k1-tbl on RS, p1-tbl on WS
	4/4 RC (see Stitch Guide)
	4/4 LC (see Stitch Guide)
	5/5 RC (see Stitch Guide)
	5/5 LC (see Stitch Guide)
	6/6 RC (see Stitch Guide)
	6/6 LC (see Stitch Guide)

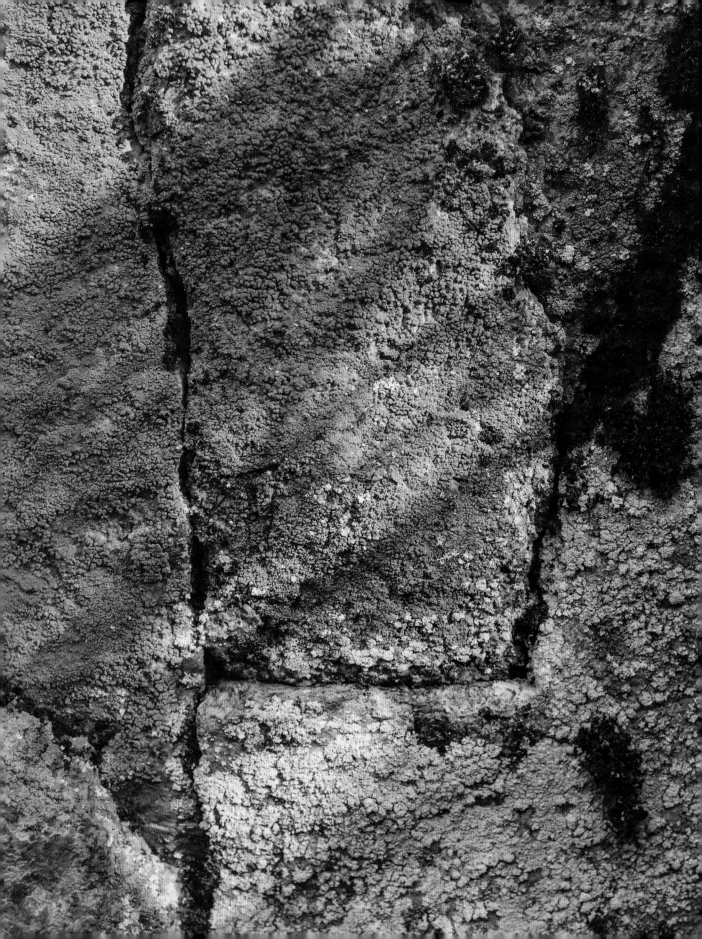

Abbreviations

approx	approximately	**rep**	repeat(s), repeating
beg	begin(s), beginning	**rnd(s)**	round(s)
BO	bind off	**RS**	right side
cir	circular	**s2kp**	slip 2, knit 1, psso
cn	cable needle	**sk2p**	slip 1, k2tog, psso
CO	cast on	**skp**	slip 1 stitch knit-wise, knit 1, pass slipped stitch over (decrease)
cont	continue(s), continuing		
dec('d)	decrease(d), decreasing	**sl**	slip
dpn	double-pointed needle(s)	**sm**	slip marker
		ssk	slip, slip, knit
inc('d)	increase(s), increasing	**ssp**	slip, slip, purl
		St st	stockinette stitch
k	knit	**st(s)**	stitch(es)
k1f&b	knit into the front and back of the same stitch	**tbl**	through the back loop
		tog	together
k2tog	knit 2 together	**WS**	wrong side
k3tog	knit 3 together	**wyb**	with yarn in back
k4tog	knit 4 together	**wyf**	with yarn in front
kwise	knitwise, as if to knit	**w&t**	wrap and turn
		yo	yarn over
LH	left hand	*****	repeat starting point
m	marker(s)		
M1L	make one left	*** ***	repeat all instructions between asterisks
M1R	make one right		
p	purl	**()**	alternate measurements and/or instructions
patt(s)	pattern(s)		
pm	place marker	**[]**	work instructions as a group a specified number of times
psso	pass slipped stitch over		
p2tog	purl 2 together		
rem	remain(s), remaining		

Glossary

Bind-offs

JENY'S SURPRISINGLY STRETCHY BIND-OFF

Step 1: If the stitch to be bound off is a knit stitch, work a backward yo (bring yarn to the front over the needle; **Figure 1**). Knit the next stitch, then insert left needle into yo and lift it over the knit stitch **(Figure 2)**. If the stitch to be bound off is a purl stitch, work a standard yo **(Figure 3)**. Purl the next stitch, then insert left needle into yo and lift it over the purl stitch **(Figure 4)**.

Step 2: Repeat step 1 for the second stitch to be bound off. Insert left needle into second stitch from tip of right needle and lift it over the next stitch.

Repeat step 2 until all stitches have been bound off. As you get into the rhythm of this method, you may prefer to lift the yo and the previous stitch over the next stitch together in a single motion **(Figure 5)**.

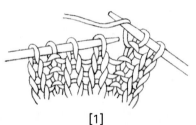

[1]

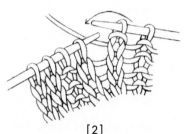

[2]

[3]

[4]

[5]

I-CORD BIND OFF

When there are live stitches or picked-up stitches on left needle: With right side facing, cast on number of stitches needed for I-cord (as directed in pattern) onto left needle. *Knit to last I-cord stitch (e.g., if working a two-stitch I-cord as shown, knit one), knit two together through the back loops **(Figures 1 and 2)**, and transfer all stitches from right needle to left needle **(Figure 3)**. Repeat from * until required number of stitches have been bound off.

[1]

[2]

[3]

SEWN BIND-OFF

Cut the yarn three times the width of the knitting to be bound off, and thread onto a tapestry needle. Working from right to left, *insert tapestry needle purlwise (from right to left) through first two stitches **(Figure 1)** and pull the yarn through, then bring needle knitwise (from left to right) through the first stitch **(Figure 2)**, pull the yarn through, and slip this stitch off the knitting needle. Repeat from *.

[1]

[2]

Cast-ons

BACKWARD LOOP CAST-ON

*Loop working yarn as shown and place it on needle backward (with right leg of loop in back of needle). Repeat from *.

CABLE CAST-ON

If there are no established stitches, begin with a slipknot, knit one stitch in slipknot, and slip this new stitch knitwise to left needle. *For a purl stitch, insert right needle from back to front between first two stitches on left needle. Wrap yarn as if to purl. Draw yarn through to complete stitch and slip this new stitch knitwise to the left needle. For a knit stitch, insert right needle from front to back between first two stitches on left needle. Wrap yarn as if to knit. Draw yarn through to complete stitch and slip this new stitch knitwise to the left needle. Repeat from *.

CROCHET PROVISIONAL CAST-ON

With smooth, contrasting waste yarn and crochet hook, make a loose chain of about four stitches more than you need to cast on. Cut yarn and pull tail through last chain to secure. With needle, working yarn, and beginning two stitches from last chain worked, pick up and knit one stitch through the back loop of each chain **(Figure 1)** for desired number of stitches. Work the piece as desired, and when you're ready to use the cast-on stitches, pull out the crochet chain to expose the live stitches **(Figure 2)**.

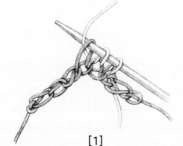

[1]

[2]

LONG TAIL CAST-ON

Leaving a long tail (about 1–2" for each stitch to be cast on), make a slipknot and place on right needle. Place thumb and index finger of left hand between yarn ends so that working yarn is around index finger and tail end is around thumb. Secure ends with your other fingers and hold palm upwards, making a V of yarn **(Figure 1)**. Bring needle up through loop on thumb **(Figure 2)**, grab first strand around index finger with needle, and go back down through loop on thumb **(Figure 3)**. Drop loop off thumb and, placing thumb back in V configuration, tighten resulting stitch on needle **(Figure 4)**.

[1]

[2]

[3]

[4]

LONG TAIL TUBULAR CAST-ON

Leaving a tail as for long tail cast-on, make a slipknot on right needle (counts as the first purl stitch). Insert your left thumb and index finger between two strands, with tail end on thumb side. To create the next knit stitch **(Figure 1)**, bring needle toward you, under front strand, up between strands, over back strand to grab it and pull it under front strand to make loop on needle. To create the next purl stitch **(Figures 2 and 3)**, take needle away from you, over both strands, under both strands, up to grab front strand and pull it under back strand to make loop on needle. Continue alternating knit and purl stitches, ending with a knit stitch. Turn work. Keeping strands crossed to preserve the last cast-on stitch, work 1 row as foll: *p1, k1; rep from * to end.

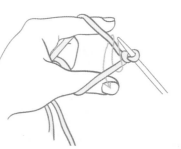

[1]

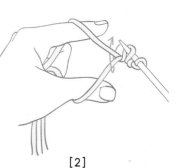

[2]

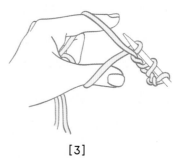

[3]

PROVISIONAL CAST-ON

Place a loose slipknot on needle held
in your right hand. Hold waste yarn next
to slipknot and around left thumb; hold
working yarn over left index finger. *Bring
needle forward under waste yarn, over
working yarn, grab a loop of working yarn
(Figure 1), then bring needle to the front,
over both yarns, and grab a second loop
(Figure 2). Repeat from *. When you're
ready to use the cast-on stitches, pick
out waste yarn to expose live stitches.

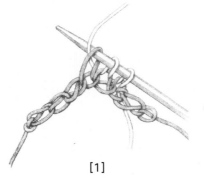

[1]

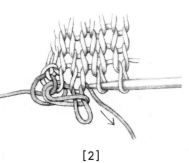

[2]

Grafting

KITCHENER STITCH

To begin the Kitchener Stitch:

Step 1: Bring threaded needle through
front stitch as if to purl and leave stitch on
needle **(Figure 1)**.

Step 2: Bring threaded needle through
back stitch as if to knit and leave stitch on
needle **(Figure 2)**.

Step 3: Bring threaded needle through
first front stitch as if to knit and slip this
stitch off needle. Bring threaded needle
through next front stitch as if to purl and
leave stitch on needle **(Figure 3)**.

Step 4: Bring threaded needle through
first back stitch as if to purl and slip this
stitch off needle. Bring needle through
next back stitch as if to knit and leave
stitch on needle **(Figure 4)**.

Repeat Steps 3 and 4 until no stitches
remain on needles.

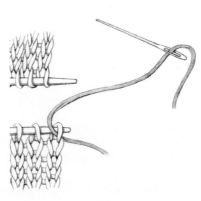

[1]

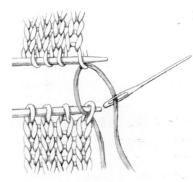

[2]

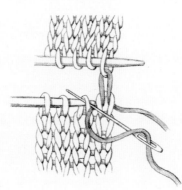

[3]

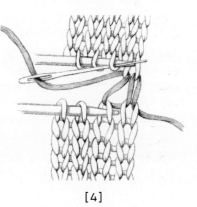

[4]

Increases

BAR INCREASE (K1F&B)

Knit into a stitch but leave the stitch on the left needle, then knit through the back loop of the same stitch and slip the original stitch off the needle, from Nicky Epstein's *Knitted Embellishments* (Interweave Press, 1999).

MAKE ONE (M1)

Left Leaning

With left needle tip, lift strand between needles from front to back **(Figure 1)**. Knit lifted loop through the back **(Figure 2)**.

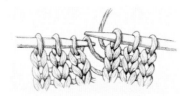

[1]

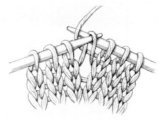

[2]

Right Leaning

With left needle tip, lift strand between needles from back to front **(Figure 1)**. Knit lifted loop through the front **(Figure 2)**.

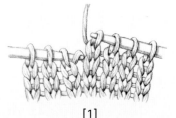

[1]

[2]

Magic Loop Method

Using a 32" or 40" (80 or 100 cm) circular needle, cast on the desired number of stitches. Slide the stitches to the center of the cable, then fold the cable and half of the stitches at the midpoint, then pull a loop of the cable between the stitches—half of the stitches will be on one needle tip and the other half will be on the other tip **(Figure 1)**. Hold the needle tips parallel so that the working yarn comes out of the right-hand edge of the back needle. *Pull the back needle tip out to expose about 6" (15 cm) of cable and use that needle to knit the stitches on the front needle **(Figure 2)**. At the end of those stitches, pull the cable so that the two sets of stitches are at the ends of their respective needle tips, turn the work around, and repeat from * to complete one round of knitting.

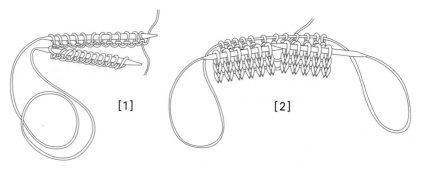

[1] [2]

Mattress Stitch

(SEAMING)

With RS of knitting facing, use threaded needle to pick up one bar between first two stitches on one piece **(Figure 1)**, then corresponding bar plus the bar above it on other piece **(Figure 2)**. *Pick up next two bars on first piece, then next two bars on other piece **(Figure 3)**. Repeat from * to end of seam, finishing by picking up last bar (or pair of bars) at the top of first piece.

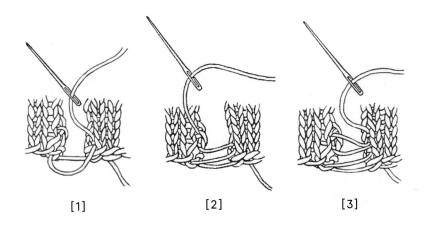

[1] [2] [3]

Pick Up & Knit

With right side facing and working from right to left, insert right needle tip into center of stitch below the cast on or bind off edge **(Figure 1)**. Wrap the yarn around the needle, and pull through a loop **(Figure 2)**. Pick up 1 st for every existing stitch.

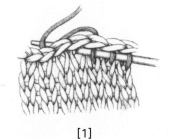

[1]

[2]

Pom-Pom

Cut two circles of cardboard, each ½"
(1.3 cm) larger than desired finished
pom-pom width. Cut a small circle out
of the center and a small edge out of the
side of each circle **(Figure 1)**. Tie a strand
of yarn between the circles, hold circles
together, and wrap with yarn—the more
wraps, the thicker the pom-pom. Knot
the tie strand tightly and cut between
the circles **(Figure 2)**. Place pom-pom
between two smaller cardboard circles
held together with a needle, and trim the
edges **(Figure 3)**. This technique comes
from Nicky Epstein's *Knitted Embellish-
ments* (Interweave Press, 1999).

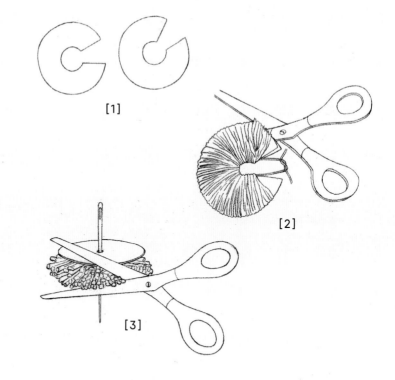

Wrap & Turn

(SHORT ROWS)

Work to turning point, slip next stitch purl-
wise **(Figure 1)**, bring the yarn to the front,
then slip the same stitch back to the left
needle **(Figure 2)**, turn the work around
and bring the yarn in position for the next
stitch—one stitch has been wrapped
and the yarn is correctly positioned to
work the next stitch. When you come to
a wrapped stitch on a subsequent knit
row, hide the wrap by working it together
with the wrapped stitch as follows: Insert
right needle tip under the wrap from the
front **(Figure 3)**, then into the stitch on the
needle, and work the stitch and its wrap
together as a single stitch

Yarn Resources

Augustbird Egret
augustbird.com.au

Berroco
berroco.com

Blue Sky Fibers
blueskyfibers.com

Cascade
CascadeYarns.com

Dragonfly Fibers
dragonflyfibers.com

Ella Rae yarns
distributed by Knitting
Fever
knittingfever.com

Julie Asselin
julie-asselin.com/en

Lakes Yarn & Fiber
lakesyarn.com

Madelinetosh
madelinetosh.com

Malabrigo
malabrigoyarn.com

Nice and Knit
niceandknit.com

Quince & Co
quinceandco.com

Western Sky Knits
wsknits.com

Woolfolk
woolfolkyarn.com

Metric Conversion Chart

To Convert	To	Multiply by
Inches	Centimeters	2.54
Centimeters	Inches	0.4
Feet	Centimeters	30.5
Centimeters	Feet	0.03
Yards	Meters	0.9
Meters	Yards	1.1

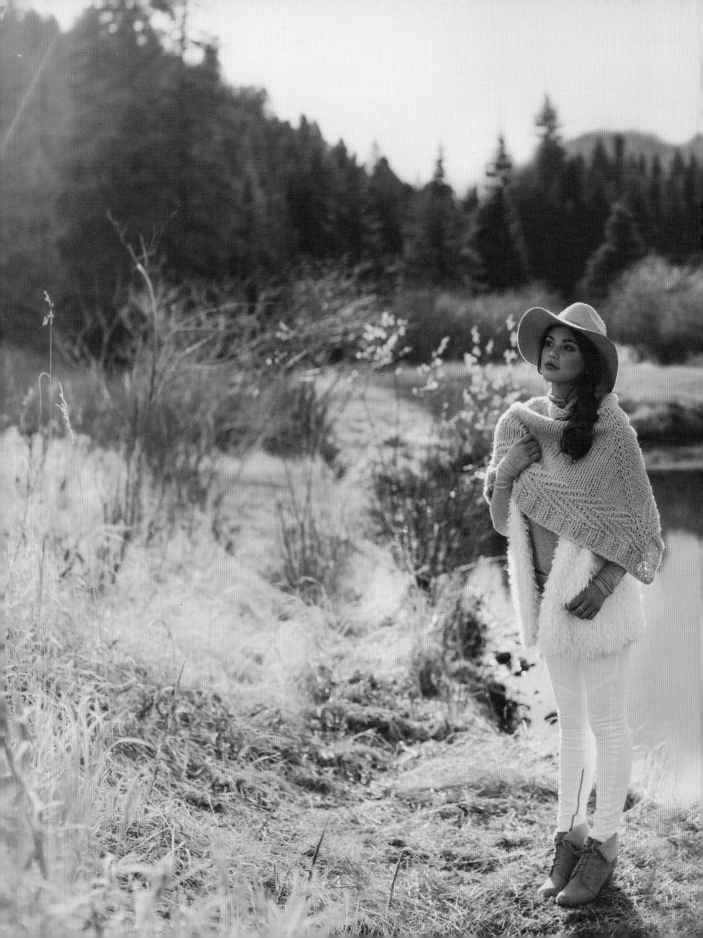

Acknowledgments

I would like to thank the incredible staff at Interweave for their help, guidance, and belief in our work.

Thank you to my family, who always supports me and allows me to follow my dreams. Thank you to the yarnies and yarn companies who have followed us along this amazing journey. You have brought so many beautiful colors and so much inspiration into our lives.

Thank you to our knitters. You are all truly amazing. Your stories have touched us; your friendships with each other and with us have been both inspiring and fulfilling. We are forever humbled and grateful beyond words.

Thank you always and forever to our Heavenly Father for finding two women living so far apart and bringing them together like long-lost sisters. All things are possible through you. ~Melissa

Thank you, Jesus, for loving me with an unconditional love that has saved me. Thank you for listening to me, walking with me, and also for helping me grow during the painful times. You sustain me. I will love you always.

Thank you to my husband Dan for being the man that I had to change nothing for. The man who sat with me in the rain to watch the fireworks on the 4th of July, the man who has stood by my side and walked through life with me, who has given me two incredibly amazing daughters. I cannot wait to see what the future holds.

Thank you to my mother, who has taught me true warmth, encouraged my artistic side, and taught me that life is full of second chances. Thank you to my mother-in-law Deb, and my entire family of in-laws: You have showed me the true meaning of a tightly knit family, and I still cannot believe how lucky I am to have each and every one of you supporting me. I love you. Last but certainly not least, Perry, and my Murphy clan. I love you.

To every single member of Plum Dandi—we are so, so, so thankful for you. We feel so blessed to have this little corner of the world to share with you. A place where everyone is welcome, everyone supports & encourages each other not only in knitting but in life. It is a truly special community! ~Alicia

Dedication

Dedicated to Avrie, Evellyn, Matthew, and Chad. I hope you always
believe in yourselves, follow your dreams, find amazing
friendships, and trust God's plan. ~Melissa

To my father, Lincoln, who brought me to Jesus, loved fearlessly,
and gave everything he had for me so I could succeed. To my grandmother, Shirley,
who taught me wisdom, responsibility, and personal discipline. To my two daughters,
Bek & Ellie: you are my world, and you will change the world someday with your incredible
compassion and love for adventure. You have changed mine in ways I never thought possible,
and you have made me a better person. ~Alicia

About the Authors

Alicia is a knitwear designer who lives in the Lakes Region of Maine. She is happily married with two incredible girls. When she isn't knitting, she's reading the Bible, hiking, kayaking, skiing, or trying new things with her family.

Melissa was born, raised, and still resides with her husband and children in the rural Midwest. She enjoys homeschooling her girls and spending time outdoors.

Alicia and Melissa met on Ravelry in 2010 at the beginning of their design careers. Even though they were miles apart and had never met in person, their friendship bloomed instantly. Nowadays, they spend hours each day on the phone sharing laughs, tears, frustrations, and joys like all best friends do. They consult with each other on every design and therefore, to some degree, each piece they individually design is collaborative.

Alicia and Melissa run the Plum Dandi group on Ravelry, where they love connecting with knitters, listening to stories, sharing laughs, and making new memories. Come join us there!

DESIGN CREDITS

Discover even more stylish pieces to knit